Currents

Water: that transparent fluid that falls from the sky and makes up our streams, lakes and oceans and covers 71% of the earth's surface. It is an essential component for all life forms on earth and plays a significant role in our lives every day, providing us with drinking and cooking water, agricultural irrigation and water to wash ourselves and clothing. Rivers and oceans provide us a way to transport items all over the world, generate power using hydroelectricity and water and steam are used as a way to provide cooling and heating as well as a way to extinguish fire.

While it can also be a source of recreational pursuits such as swimming, boating, surfing, fishing, ice skating and skiing, it can also be a powerful source of destruction causing landslides, floods, tsunamis, hurricanes, avalanches and cyclones. Just as too much of it can be destructive, so can too little, causing droughts that spark wildfires and poor crop growing conditions which impact food supply.

Currents is a juried exhibition of art quilts created by members of the SAQA Massachusetts/Rhode Island region.

Opening on August 7, 2016 at the Brush Art Gallery and Studios in Lowell Massachusetts.

Jurors: Diane Wright and Kate Themel
Curators: Sue Bleiweiss, Nancy Turbitt

www.saqa.com

The artists …

Dawn Allen — www.dawnallen.net
Christina Blais — www.onebobbin.com
Sue Bleiweiss — www.suebleiweiss.com
Ann Brauer — www.annbrauer.com
Janis Doucette — www.turtlemoonimpressions.wordpress.com
Sandy Gregg — www.sandygregg.com
Rosemary Hoffenberg — www.rosemaryhoffenberg.com
Mary-Ellen Latino — www.highinfiberart.com
Valerie Maser-Flanagan — www.valeriemaserflanagan.com
Clara Nartey — www.claranartey.com
Tricia Purrington Deck — www.triciadeck.com
Wen Redmond — www.wenredmond.com
Judy Ross — www.artquiltsbyjudyross.com
Gwyned Trefethen — www.gwynedtrefethen.com
Nancy Turbitt — www.nancyturbitt.com
Allison Wilbur — www.allisonwilburquilts.com/wp/

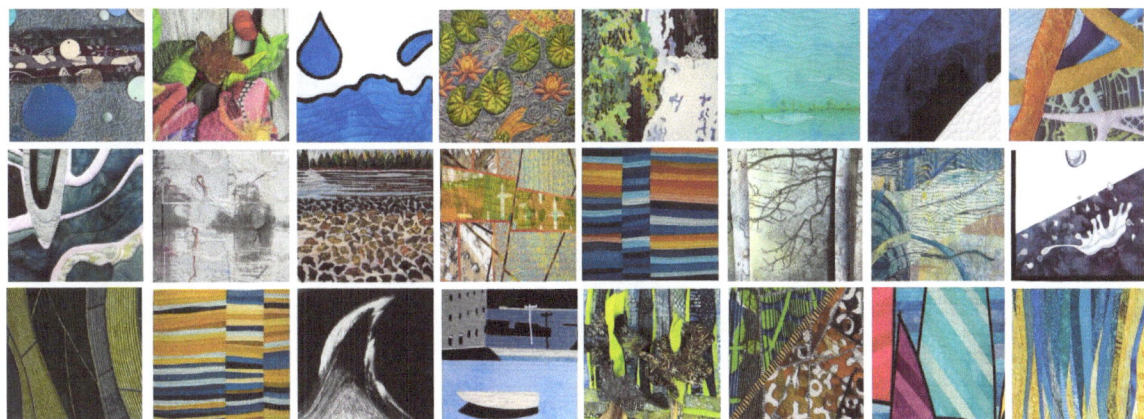

Dawn Allen

www.dawnallen.net

April showers are sometimes so dreary and cold, but they are a necessary part of our water cycle. Fortunately they also hold the promise of flowers and spring and warmer days. I wanted to capture that moment of cold rain with a glimpse of green days to come in this art quilt. Old dried oak leaves from last fall try to hold back the spring bulbs to no avail. The daffodils have decided to bloom and so it will be green soon!

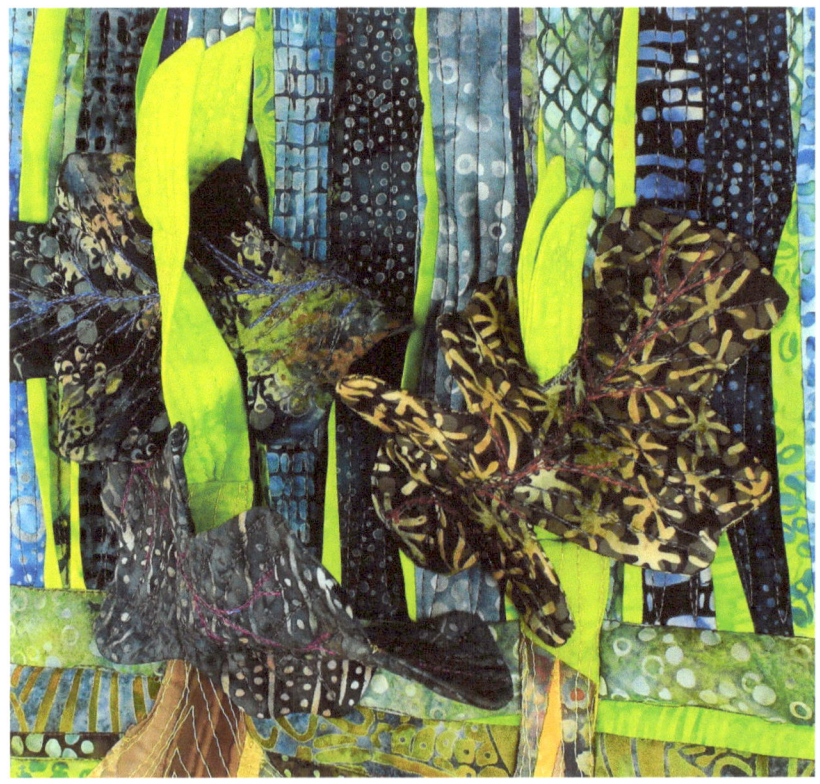

April Showers detail

April Showers

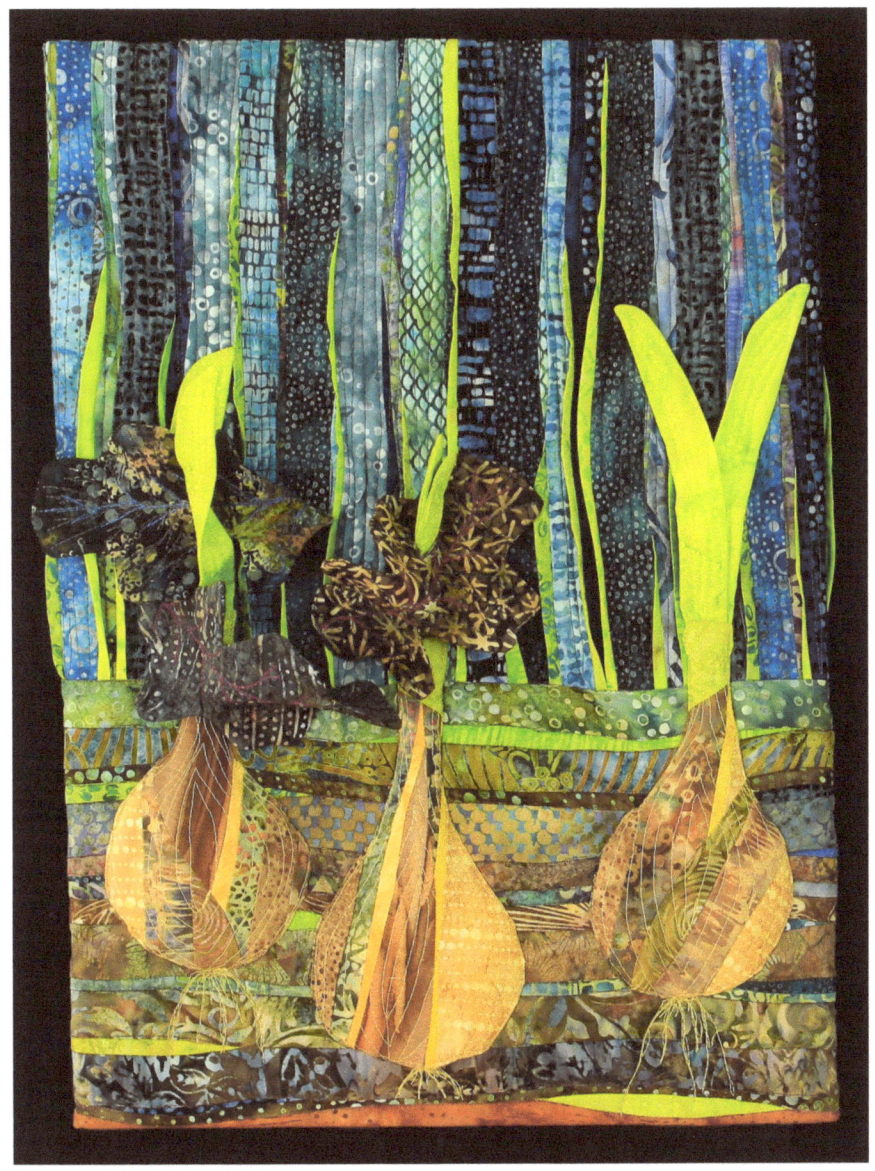

20" x 14" x 3"

Techniques: Strip piecing and free-motion quilting. Three dimensional elements get their shape from strategic tacking.

Dawn Allen

www.dawnallen.net

The moment I heard that the theme for this exhibit was "currents" I visualized Cape Cod. Almost all of my ocean experiences have been on the Cape and my family went on vacation there each year. I rarely think about "currents" when I am home in western Massachusetts, but of course it is a word we would use often at the beach. I set out to design an art quilt that would easily be recognized as Cape Cod but I didn't want it to be a literal interpretation of water and currents. I used a photo of cedar shakes for the background and created three dimensional beach roses with rosehips. Every time I look at this piece I feel happy and I swear I can smell the salt water and sand!

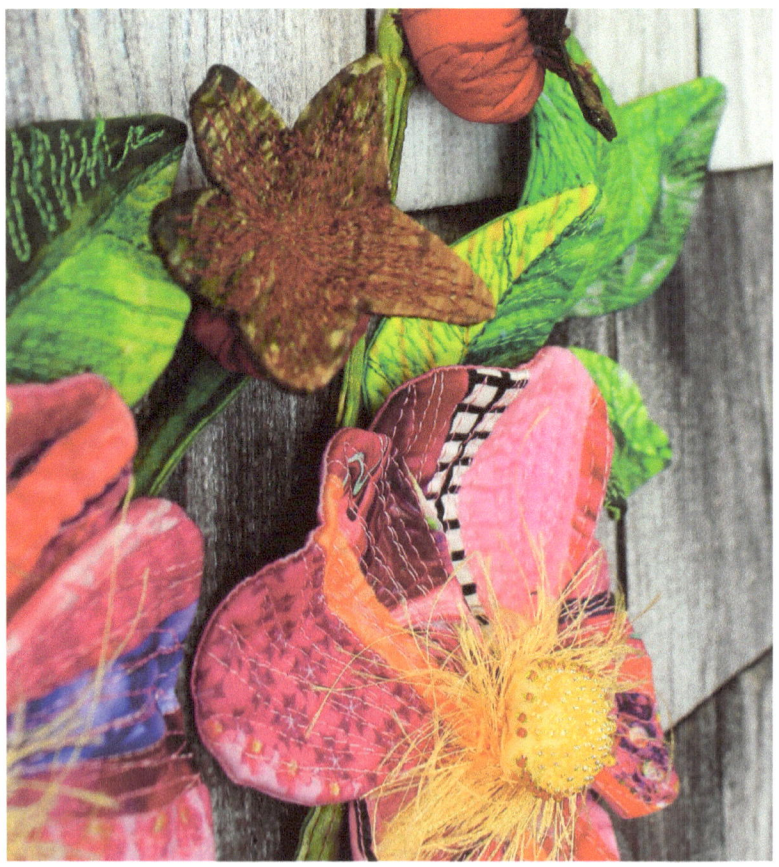

Beach Roses detail

Beach Roses

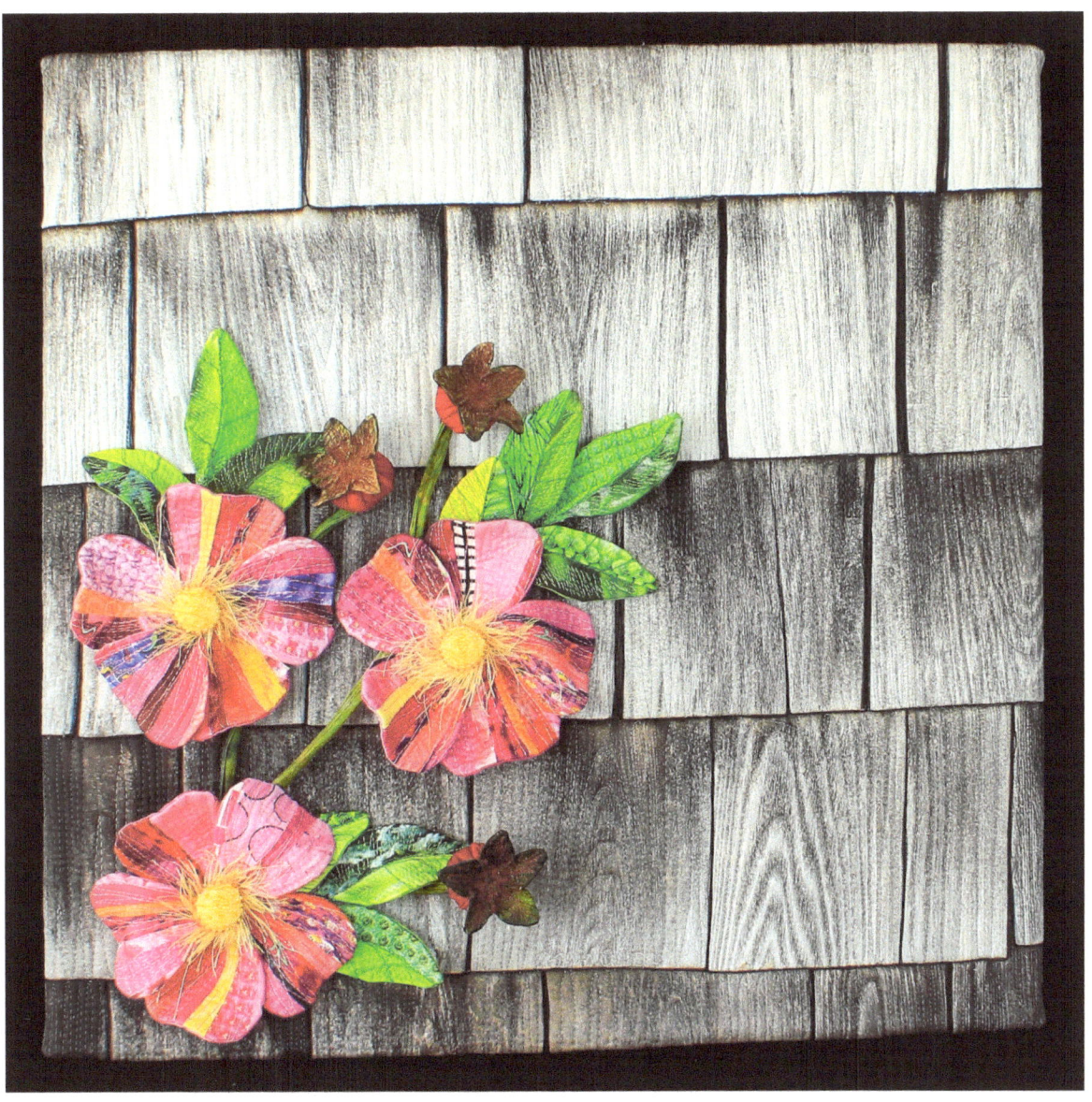

20" x 20" x 3"

Techniques: Photos were manipulated digitally to create the fabric. Other techniques included piecing, free-motion quilting, and beading.

Christina Blais

www.onebobbin.com

I consider myself a "non-fiction" quilter. I spend considerable time thinking about what I am going to convey, and in the case of IL Pleut, it was to be of a boat as seen through tears or rain. I use whatever materials and techniques I think are appropriate for the subject matter. I have done pieces that are all raw-edge appliqué, pieces that are all sewn, pieces that combine piecing and raw-edge, pieces with no embellishments, and pieces that include embellishments.

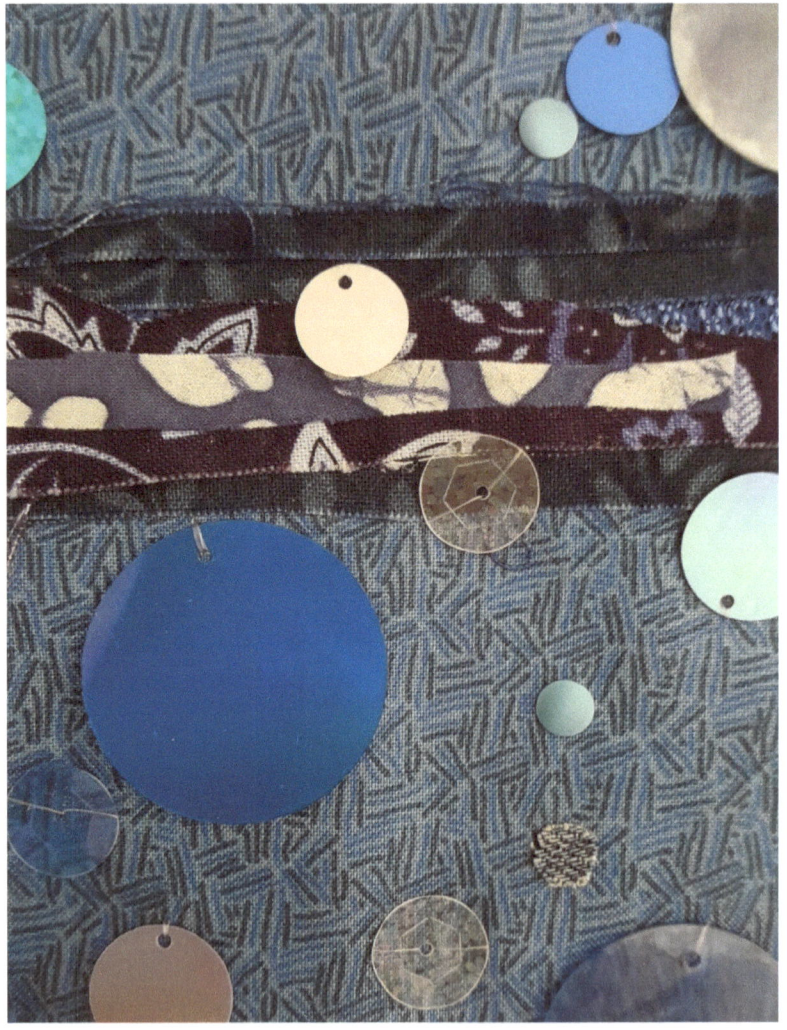

IL Pleut detail

Il Pleut

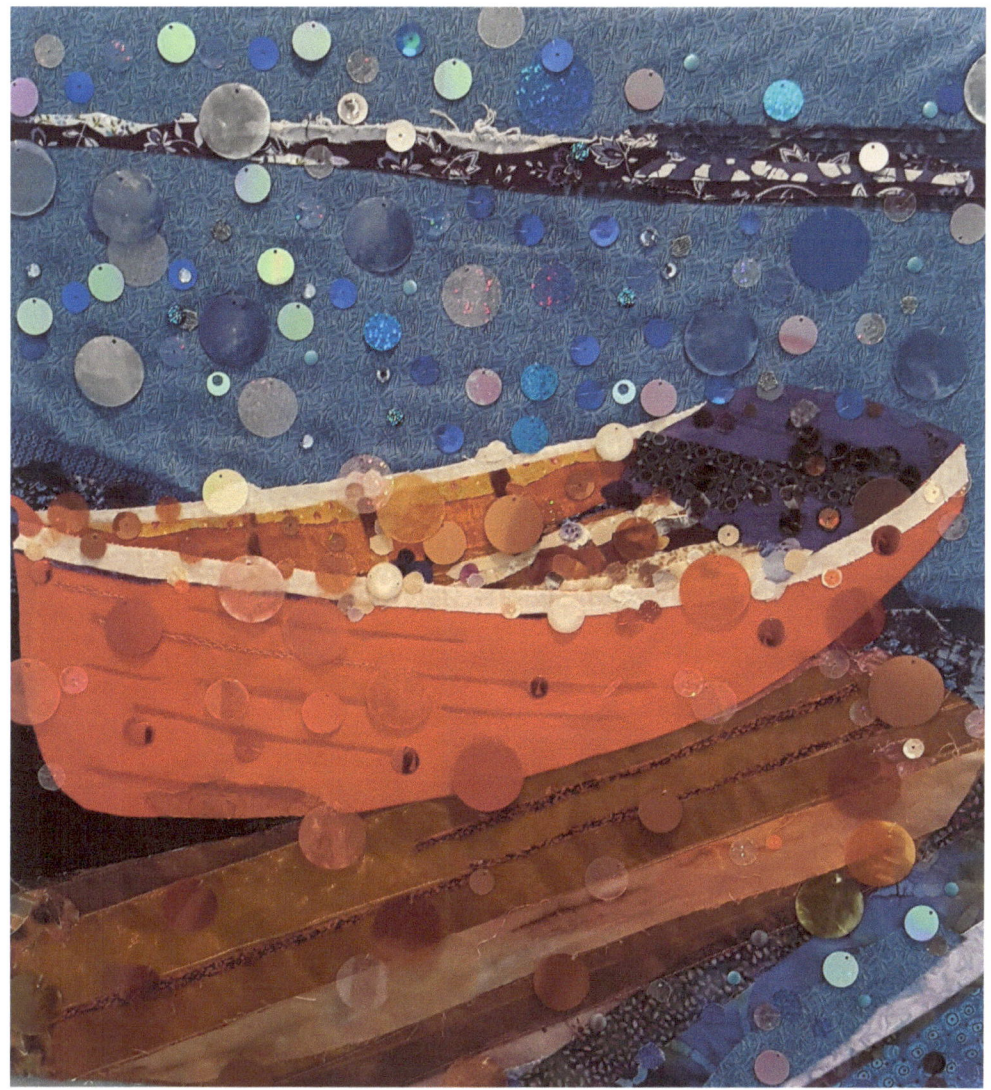

20" x 20" x 1"

Techniques: raw-edge appliqué, surface embellishment with sequins

Sue Bleiweiss

www.suebleiweiss.com

The EPA reports that the average household's leaky faucets can account for more than 10,000 gallons of water wasted every year. That amount of wasted water is the same amount needed to wash 270 loads of laundry. Those innocent little drips falling from the faucet that seem so insignificant can waste more than 1 trillion gallons annually nationwide. That's equal to the annual household water use of more than 11 million homes! That seemingly insignificant little drip has major implications and I created this quilt to illustrate that.

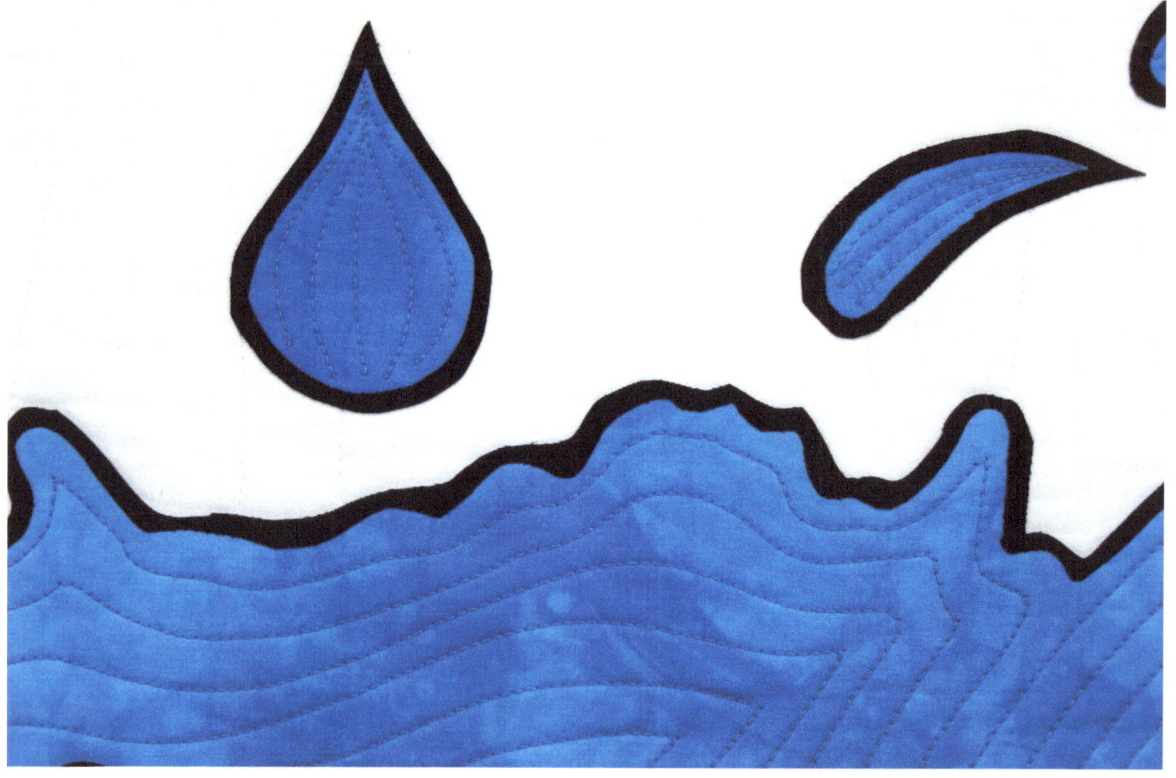

Drip detail

Drip

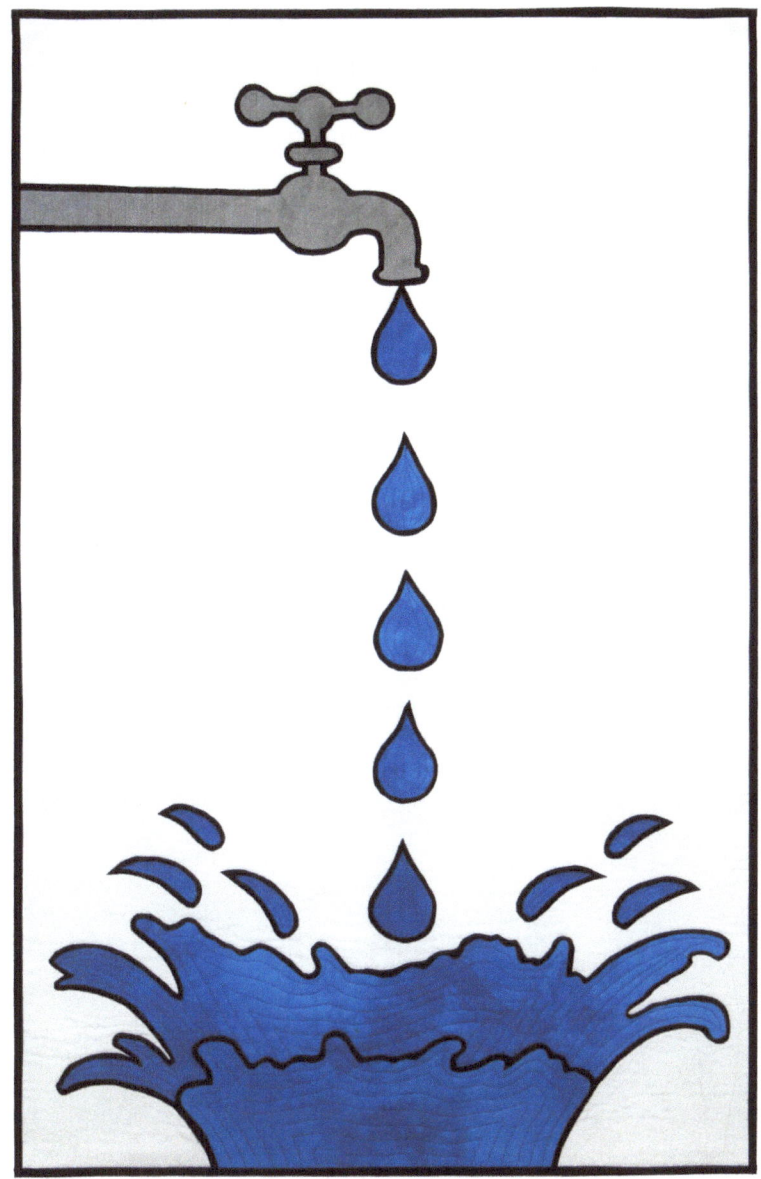

38" x 24"

Techniques: raw-edge appliqué, machine quilted

Sue Bleiweiss

www.suebleiweiss.com

I spend a lot of time on the water in the spring, summer and fall months. I love the feeling of gliding along the water with nothing but the sounds of the birds to fill my ears.

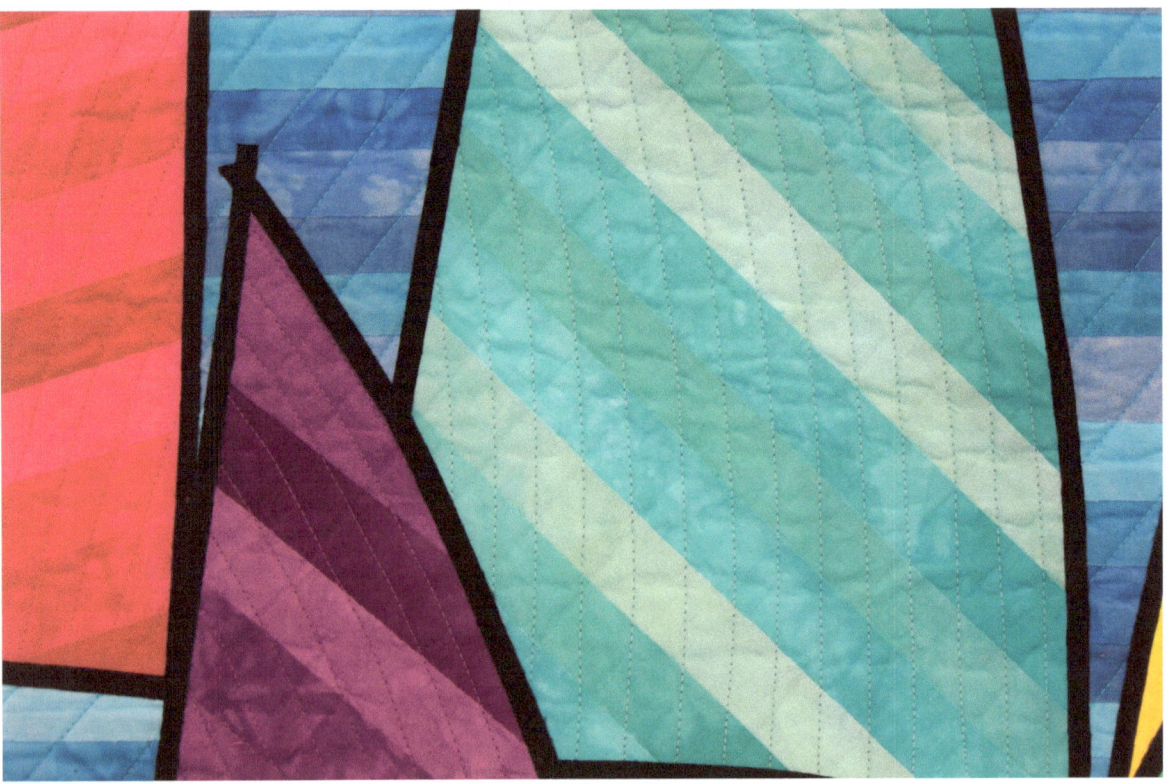

Sail detail

Sail

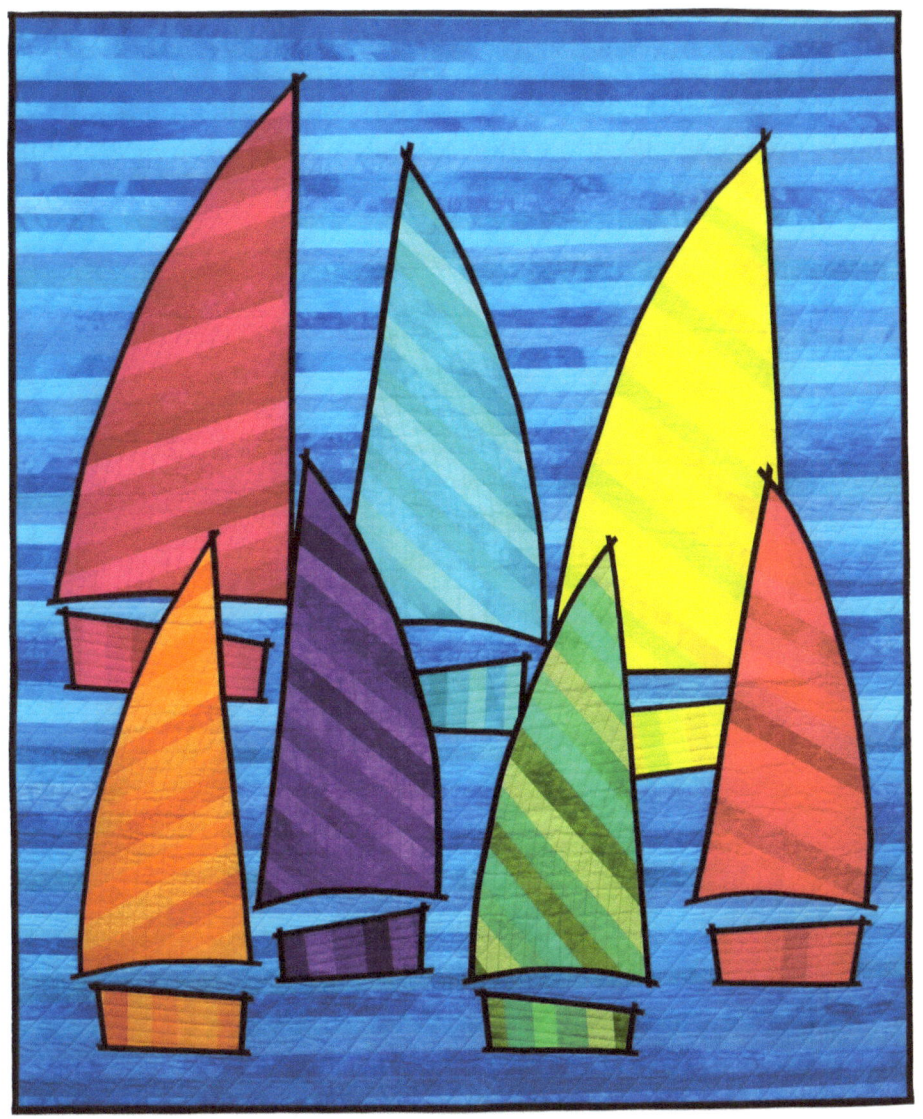

43" x 36"

Techniques: raw-edge appliqué, machine quilted

Ann Brauer

www.annbrauer.com

The motion of the water in the ocean is a constant ebb and flow. The seaweed floats against the waves crashing on the beach and the light casts wonderful reflections. This quilt is made in two blocks and joined together to reference traditional quilting.

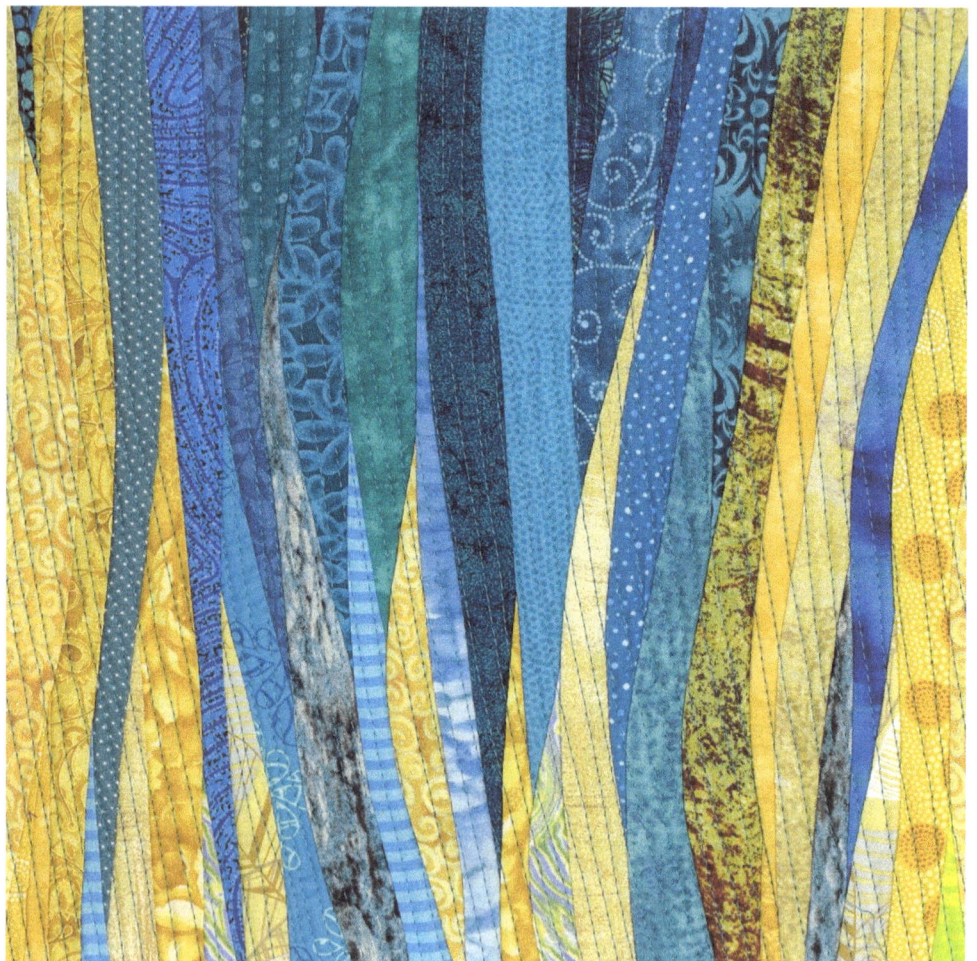

Photo by John Polak

scenes from the beach detail

scenes from the beach

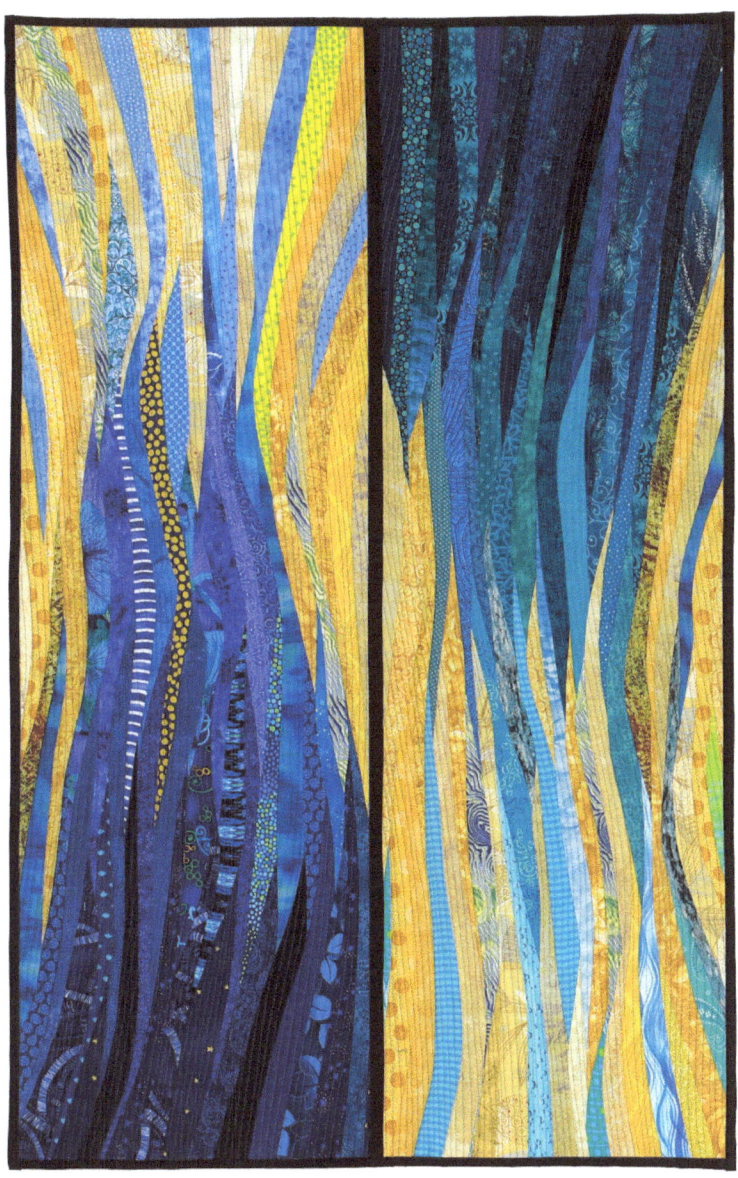

40" x 24"

Photo by John Polak

Techniques: The strips of cotton fabric are pieced through the cotton batting onto the back one at a time, each block is then intensely quilted to add even more texture and the bindings are hand finished.

Janis Doucette

www.turtlemoonimpressions.wordpress.com

Often, the images in my mind of Cape Cod are of Woods Hole because I spent quite a bit of time there when I lived on the Cape. Eel Pond is a salt water inlet. The Marine Biological Laboratories, the reference for this piece, is housed on its' shore and the entire Woods Hole Community is centered around it, the Woods Hole Consortium, the Woods Hole Oceanographic Institution, and the Woods Hole Research Center. Thus, this community thrives in a diverse exchange between the locals, the fishing community and the economy of scientific research and education. I hope I've portrayed a small part of the soul of the village in *Across The Pond*.

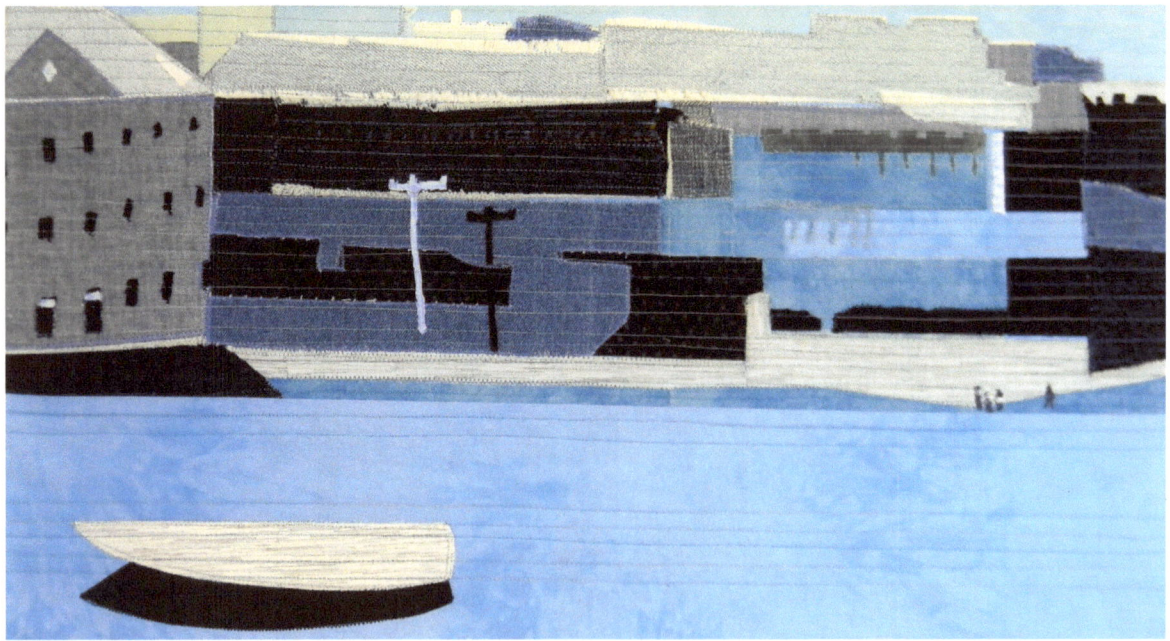

Across The Pond detail

Across The Pond

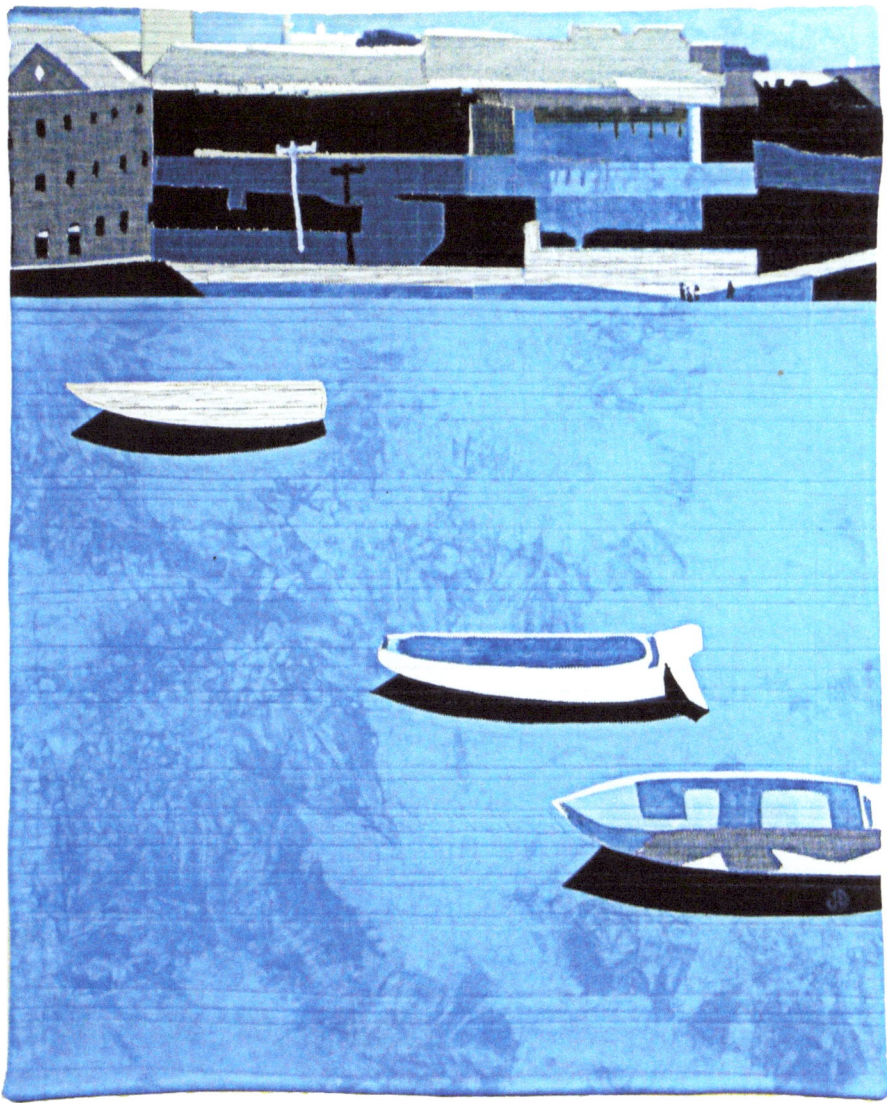

30" x 24"

Techniques: hand-cut, fused and machine pieced appliqué Most fabric is hand dyed.

Sandy Gregg

www.sandygregg.com

Water can be destructive as well as beneficial. Look around and you will see many examples of crumbling roadways and sidewalks caused by the freeze/thaw cycle that have provided an opportunity for new growth to emerge.

Photo by Joe Ofria

Crumbling Infrastructure detail

Crumbling Infrastructure

Photo by Joe Ofria

25" x 28"

Techniques: deconstructed screen printing, traditional screen printing, machine pieced and quilted

Sandy Gregg

www.sandygregg.com

For years in some areas we have been borrowing from the future by using more water than nature replenishes. That has resulted in water shortages and watering restrictions. Maybe those lush lawns are turning into a thing of the past. That's not so bad.

Photo by Joe Ofria

Global Warming: Living with Drought detail

Global Warming: Living with Drought

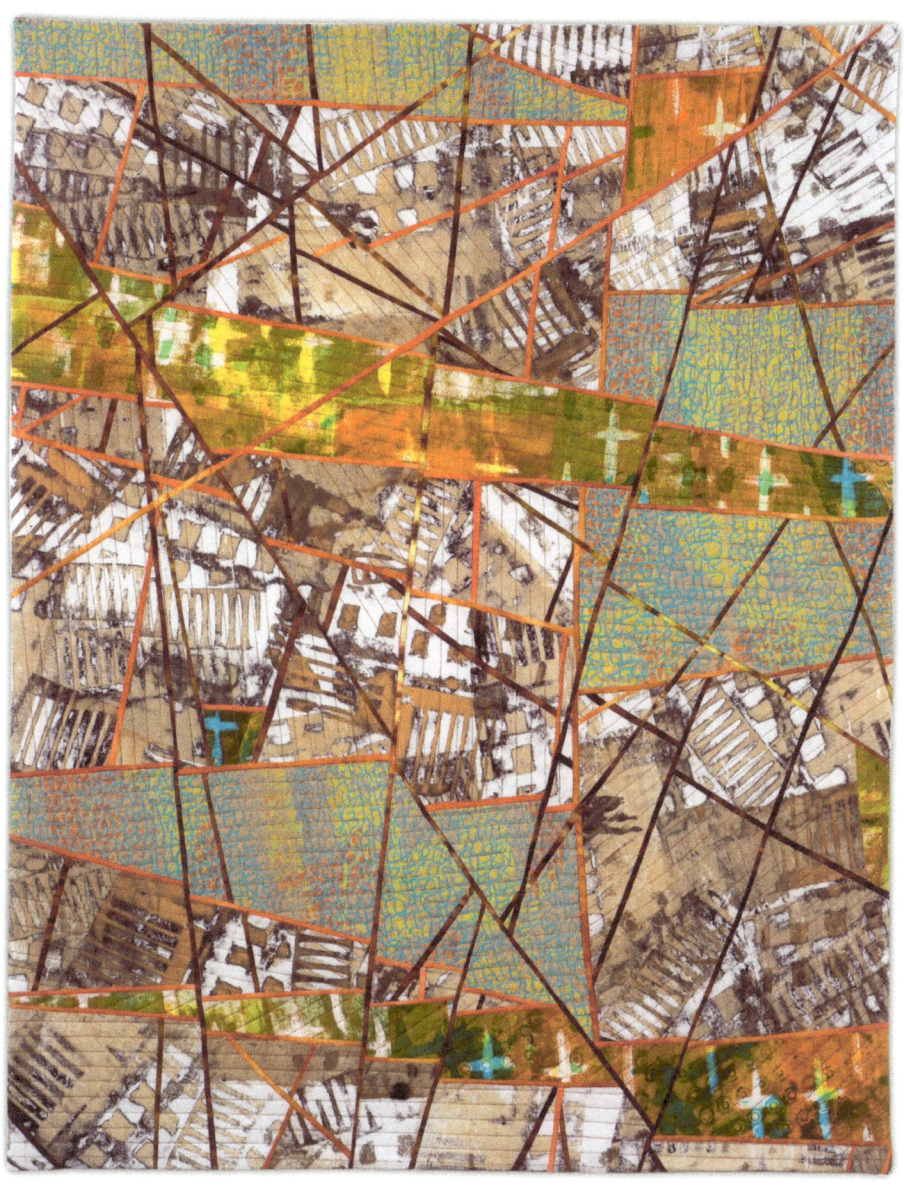

Photo by Joe Ofria

39" x 30"

Techniques: deconstructed screen printing, machine piecing

Rosemary Hoffenberg

www.rosemaryhoffenberg.com

Color, shape and their overall impact are the driving forces in my quilts. These elements are what I respond to viscerally, thus, they generate the process of my quilt design.

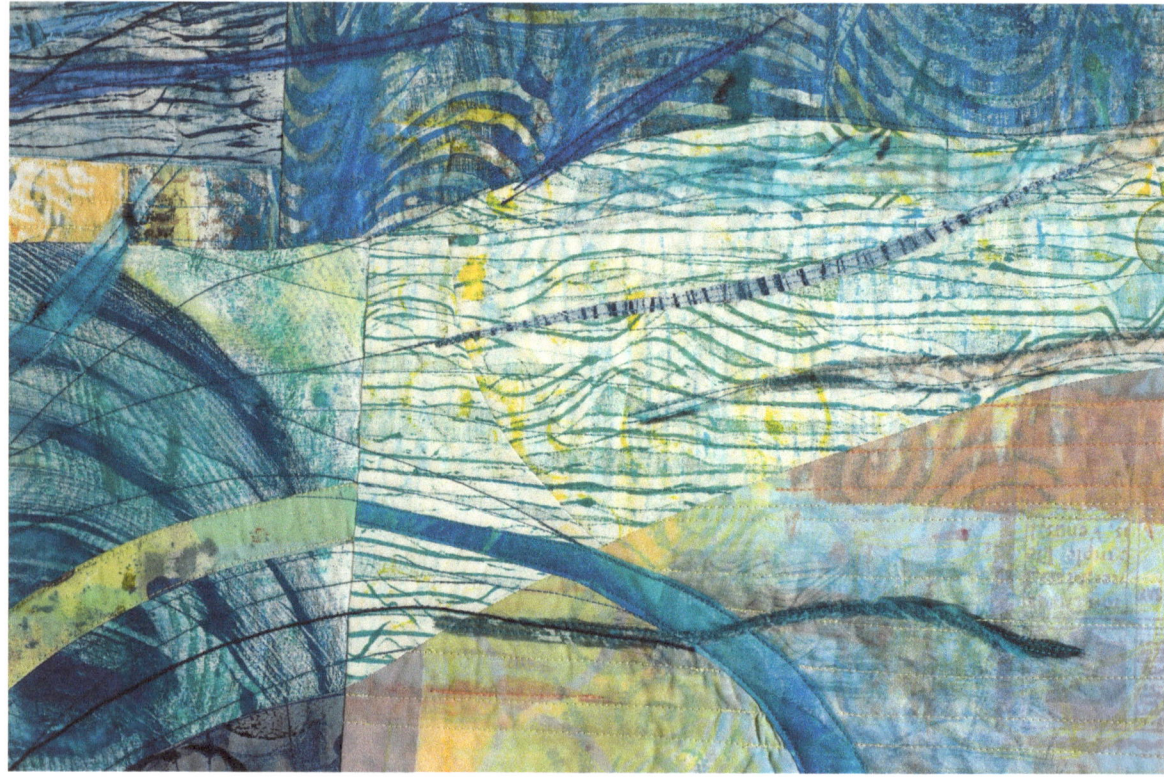

Deep Sea Currents detail

Photo by Joe Ofria

Deep Sea Currents

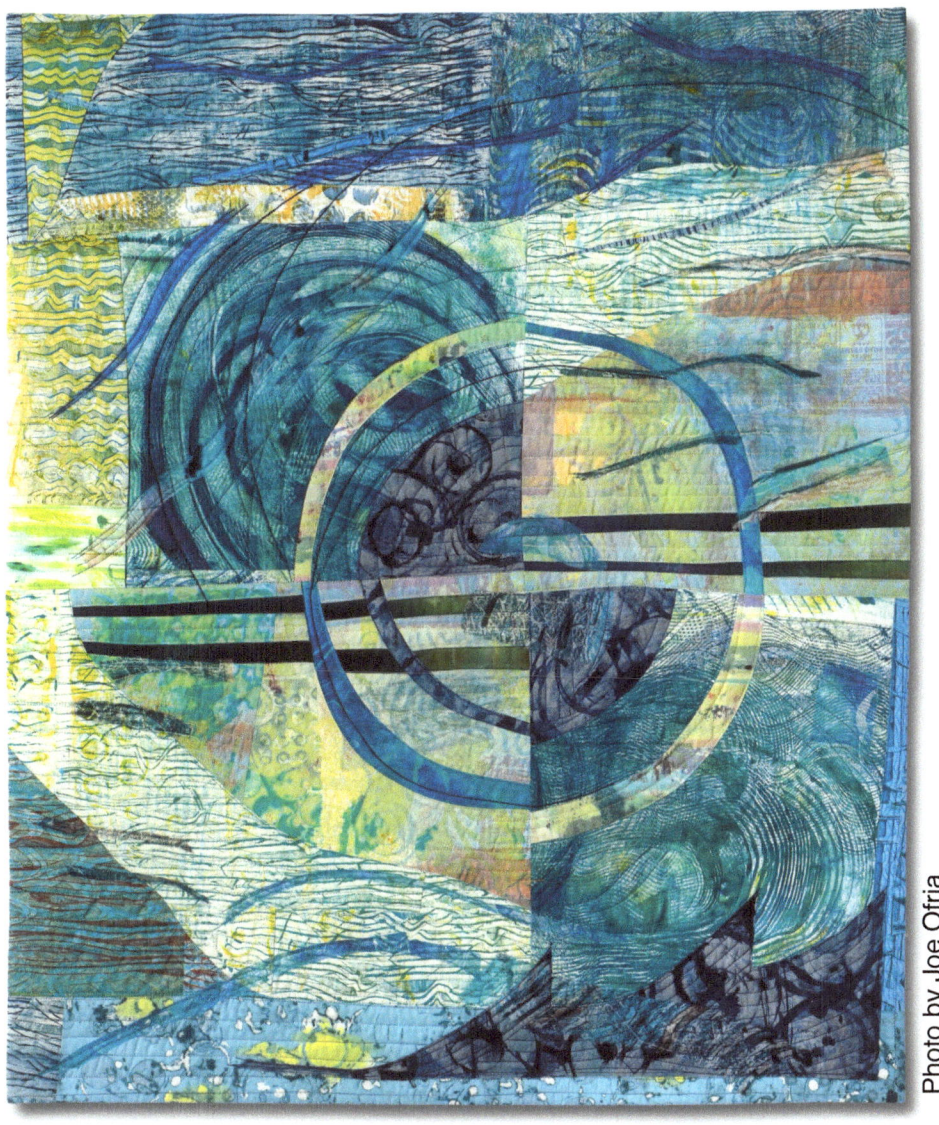

38" x 31"

Techniques: dyed, painted, mono-printed, screen printed, machine pieced, machine quilted

Mary-Ellen Latino

www.highinfiberart.com

This piece all began when I was concerned over my son going to the Philippines to work. I thought about ocean storms, the negative effects of nature and his safety while there. What if he was in the wrong place at the wrong time and was in the middle of an ocean disaster?! Although the oceans comprise the majority of the Earth's surface and contribute in limitless positive ways to our world, when an ocean's mighty powers intensify out of control it can be catastrophic. For example, a tsunami is an unyielding and overwhelming ocean wave brought on by major disturbances on the ocean floor that can cause unimaginable destruction and loss of life. Inspired by all this information and "what if" turmoil, I created *Disturbance* as a metaphor for life- "life is inexorable as the sea" (Thomas Wentworth Higginson, 1875).

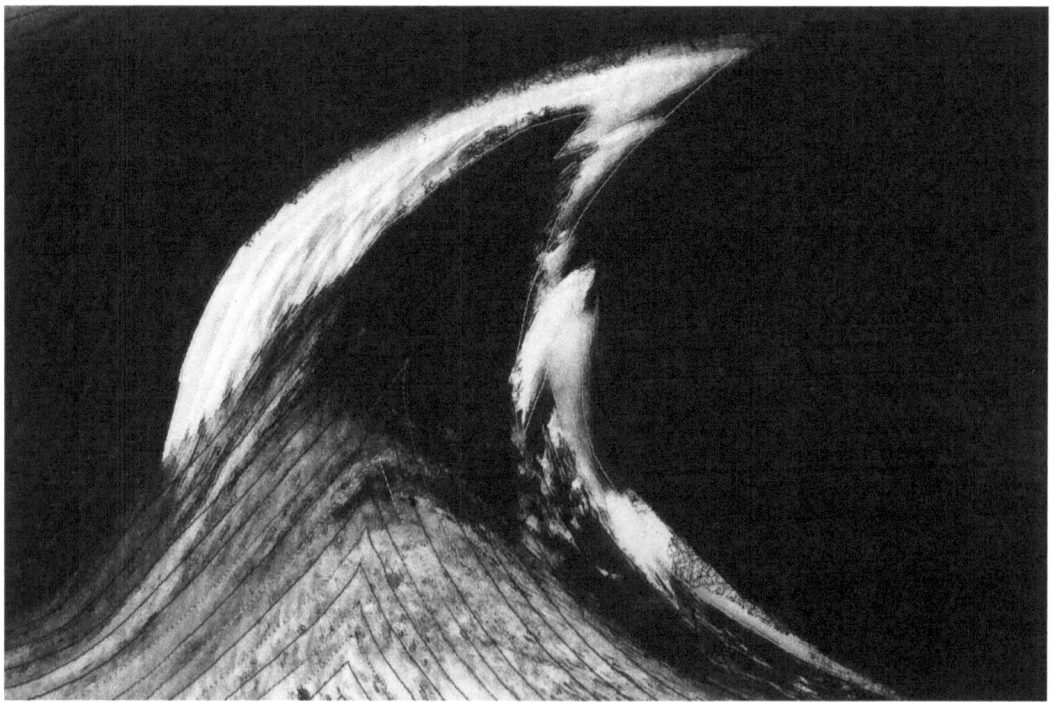

Photo by Joe Ofria

Disturbance detail

Disturbance

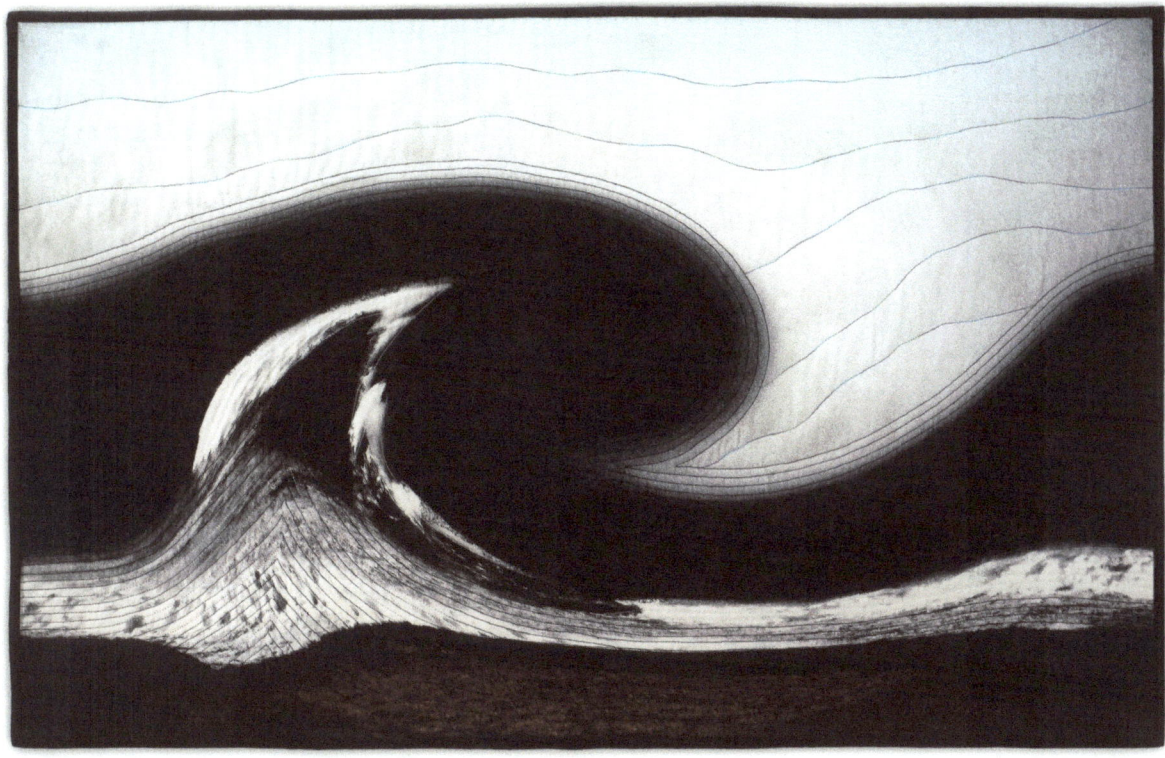

Photo by Joe Ofria

23" x 36"

Techniques: digitally developed and printed cotton, painted, foiled, free-motion machine pieced

Valerie Maser-Flanagan

www.valeriemaserflanagan.com

Inspired by the rich colors created as the sun's rays play across the water.

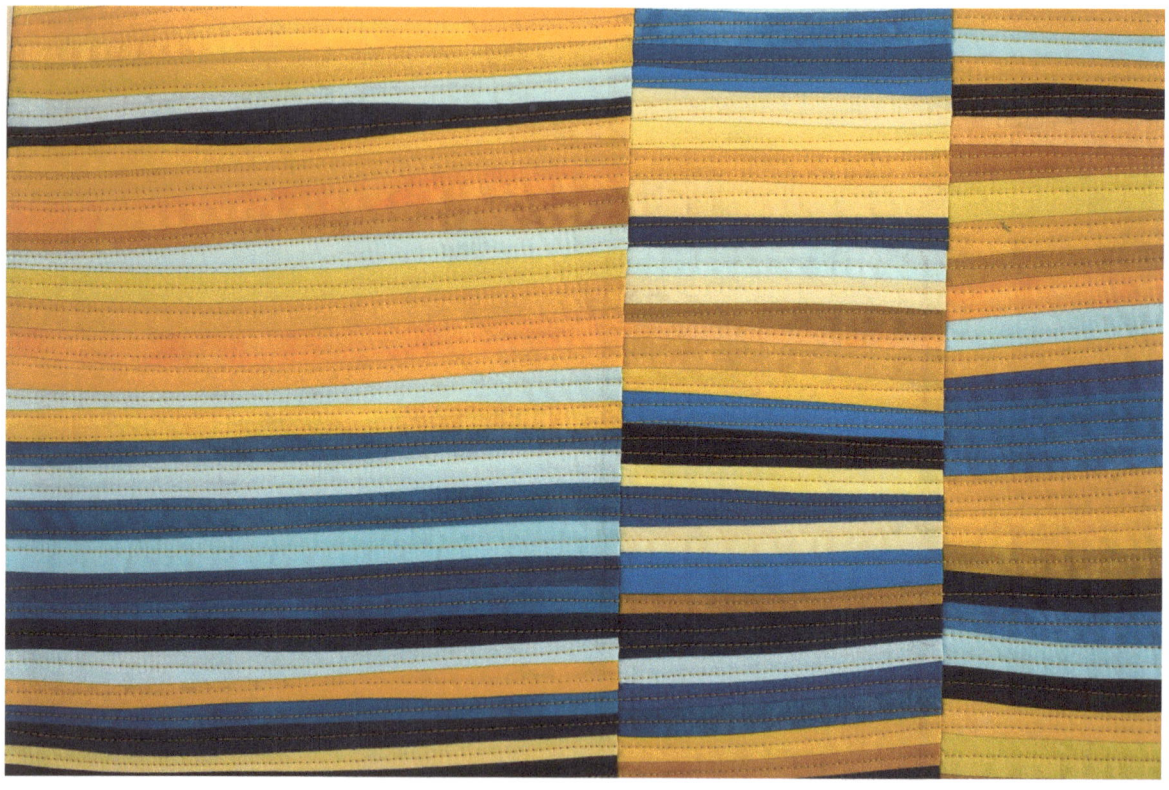

Morning Rays on the Water detail

Photo by Joe Ofria

Morning Rays on the Water

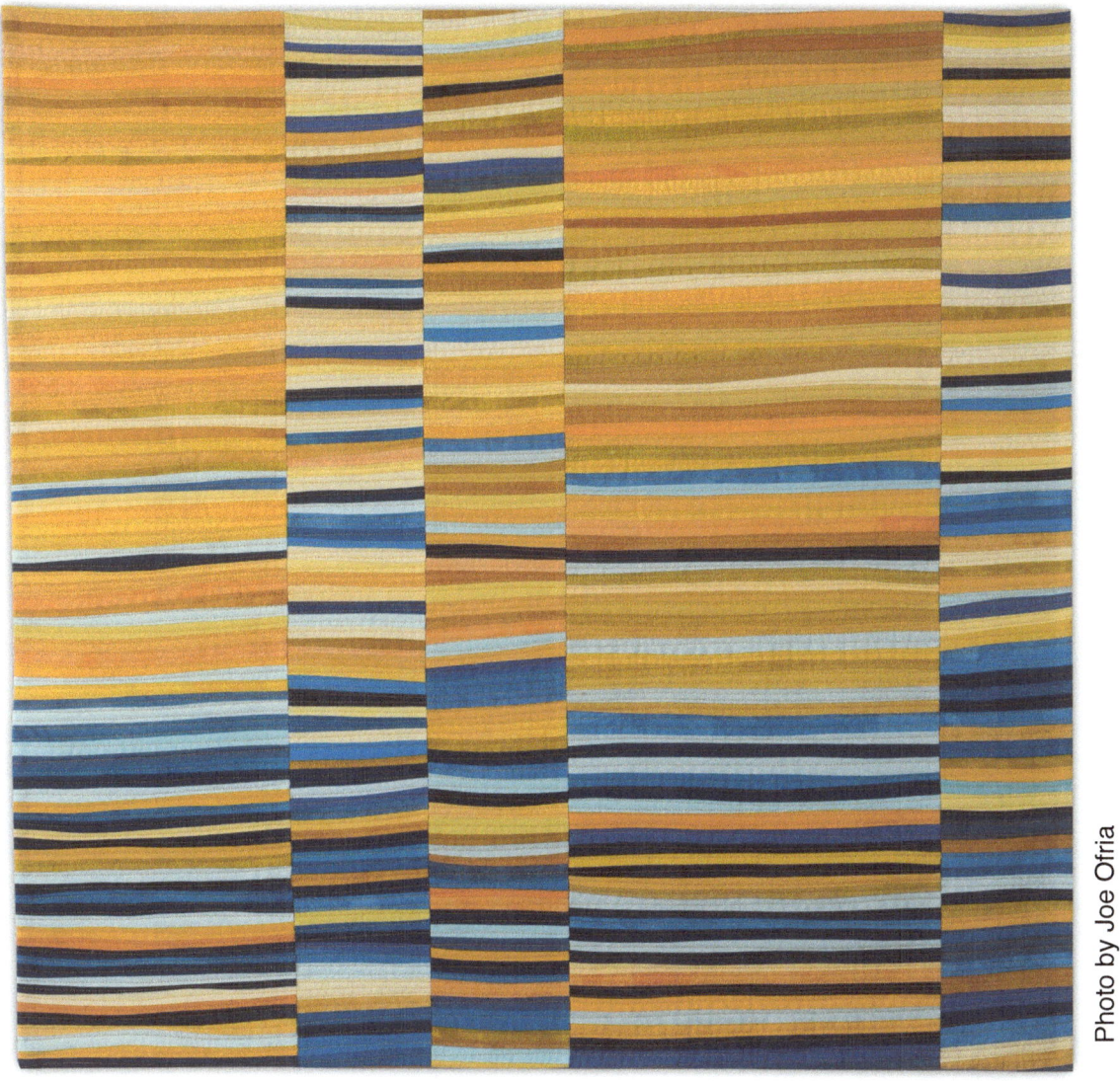

Photo by Joe Ofria

36" x 36"

Techniques: Lines and shapes were freely cut. The composition was designed improvisationally; machine pieced and machine quilted.

Valerie Maser-Flanagan

www.valeriemaserflanagan.com

Inspired by the rich colors created as the sun's rays play across the water.

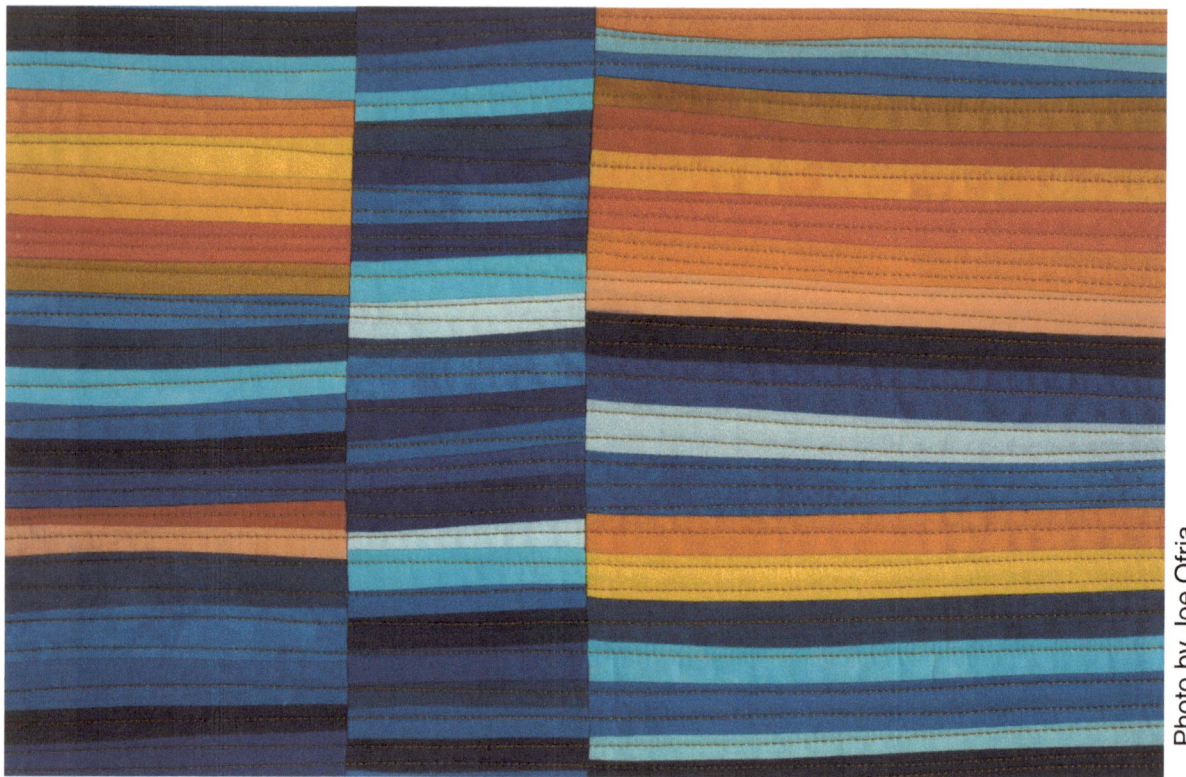

Evening Rays on the Water detail

Photo by Joe Ofria

Evening Rays on the Water

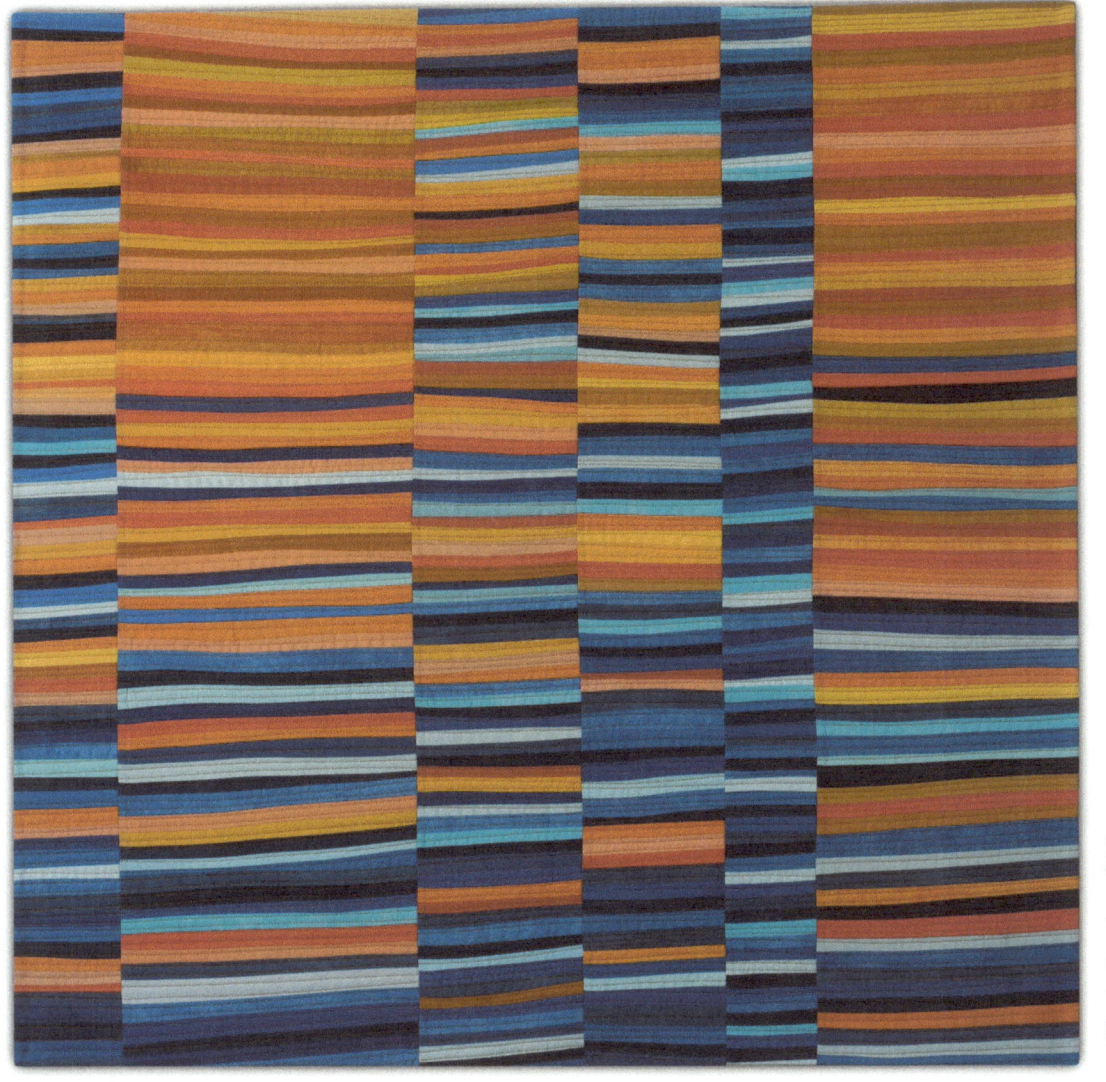

Photo by Joe Ofria

36" x 36"

Techniques: Lines and shapes were freely cut. The composition was designed improvisationally; machine pieced and machine quilted.

Valerie Maser-Flanagan

www.valeriemaserflanagan.com

Riverbeds fill with melting snow and spring rains. More remain dry as droughts caused by environmental changes such as global warming become more prevalent.

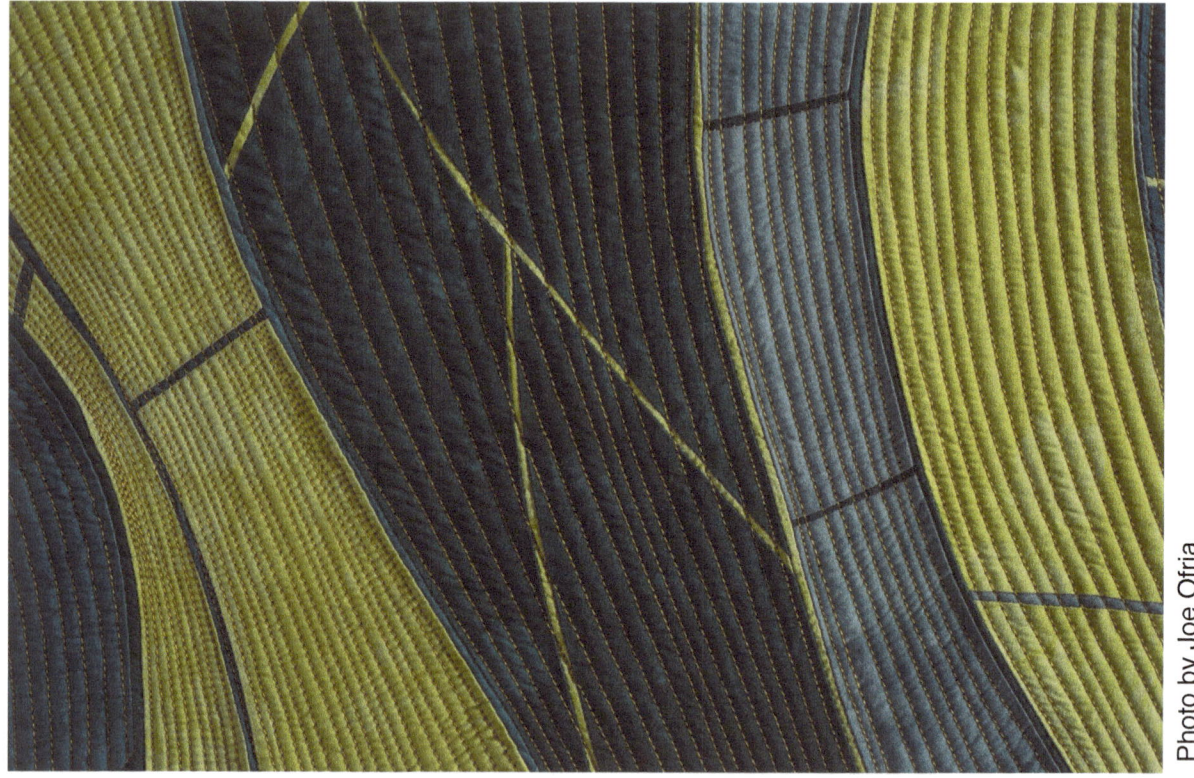

Riverbed detail

Photo by Joe Ofria

Riverbed

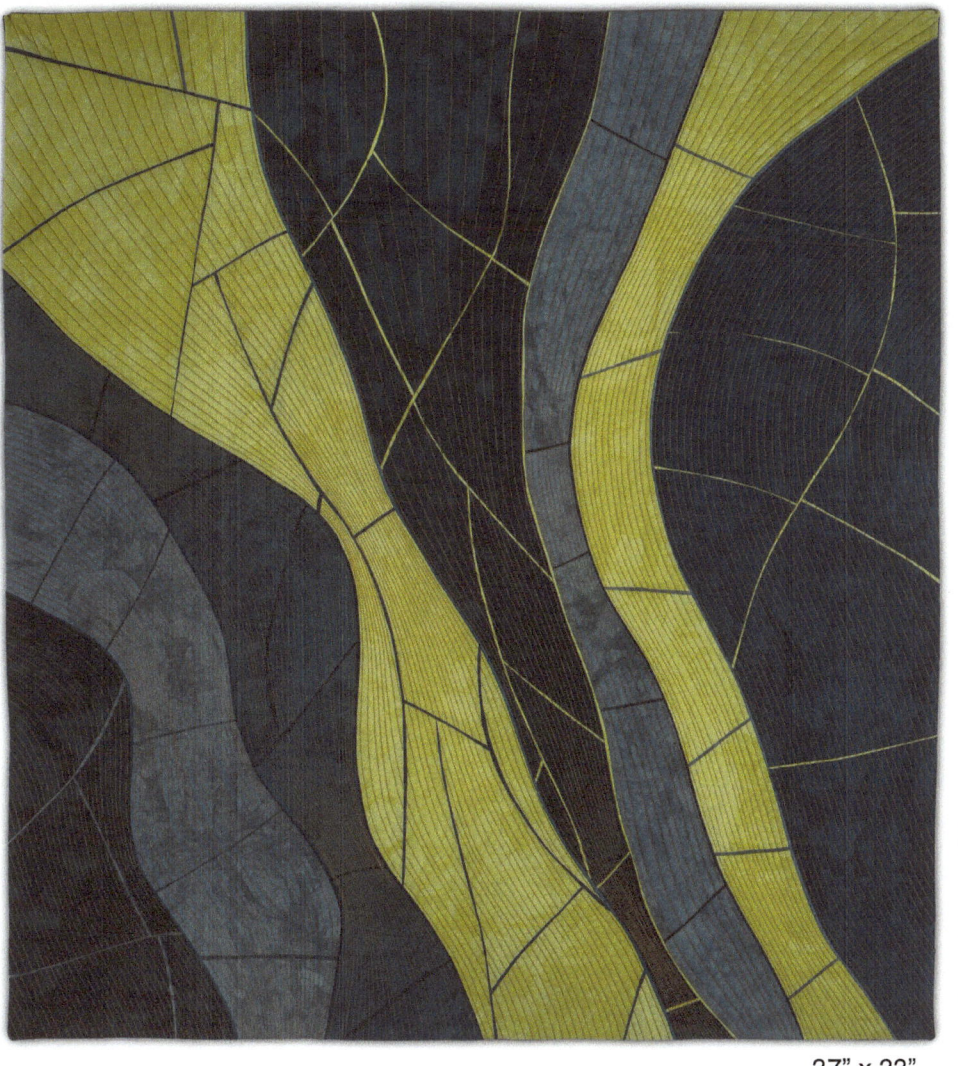

37" x 33"

Photo by Joe Ofria

Techniques: Lines and shapes were freely cut and composed improvisationally; machine pieced and machine quilted.

Clara Nartey

www.claranartey.com

"Little drops of water make a mighty ocean." Little drops come together to make a puddle, then an ocean. A little step at a time is all we need to achieve our goals. Each little step counts – it gets us closer to our destination.

Little Drops of Water detail

Little Drops of Water

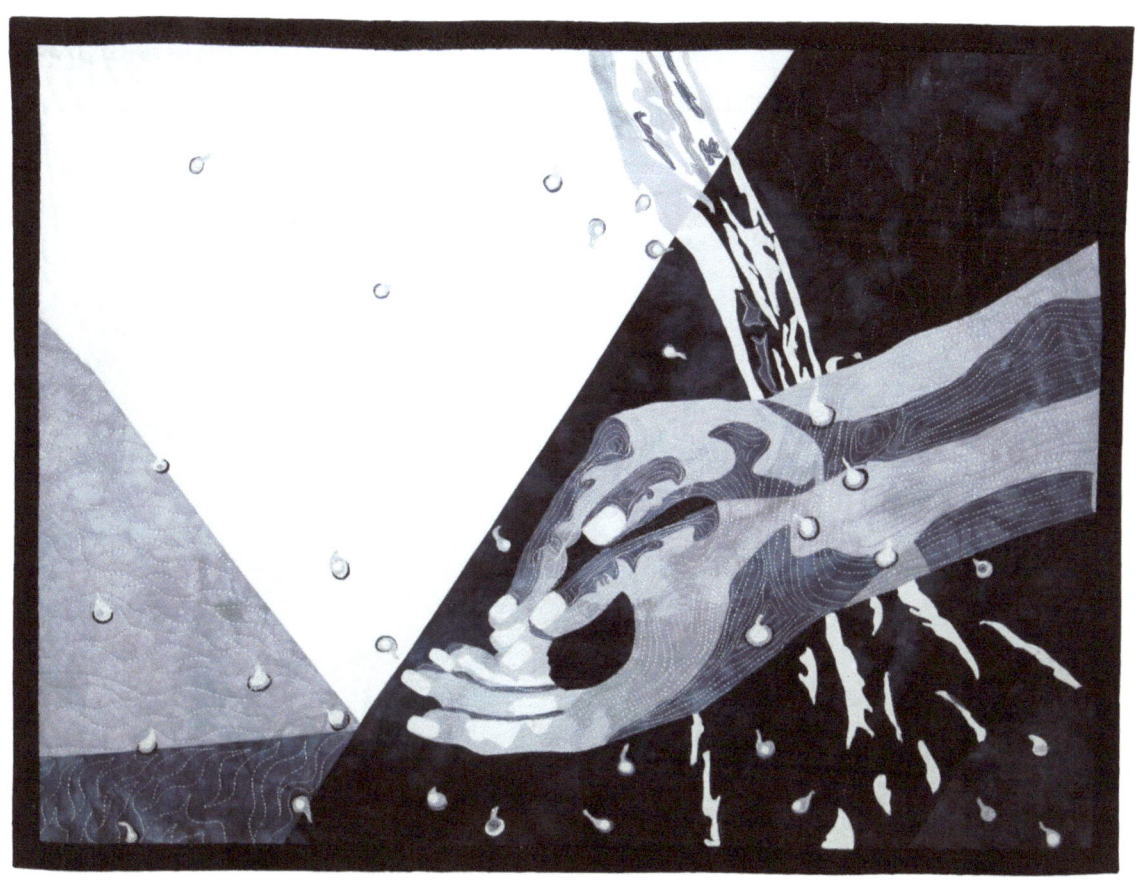

26" x 34"

Techniques: collage, stitch and dye

Clara Nartey

www.claranartey.com

In most societies, water is a source of life itself. *Splash* uses water to depict that as much as we try to hold all the pieces of life together, we are not always successful. Every now and then, we drop the ball and make a splash.

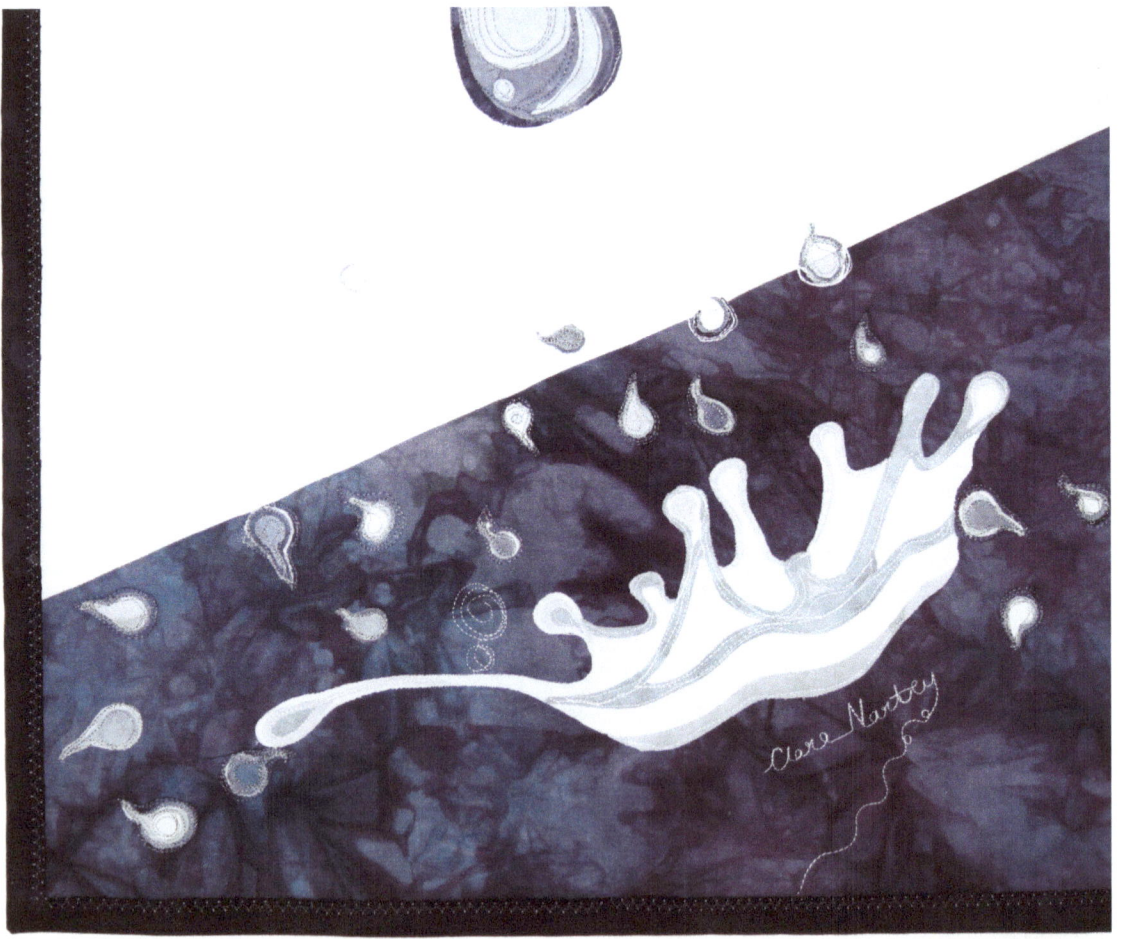

Splash detail

Splash

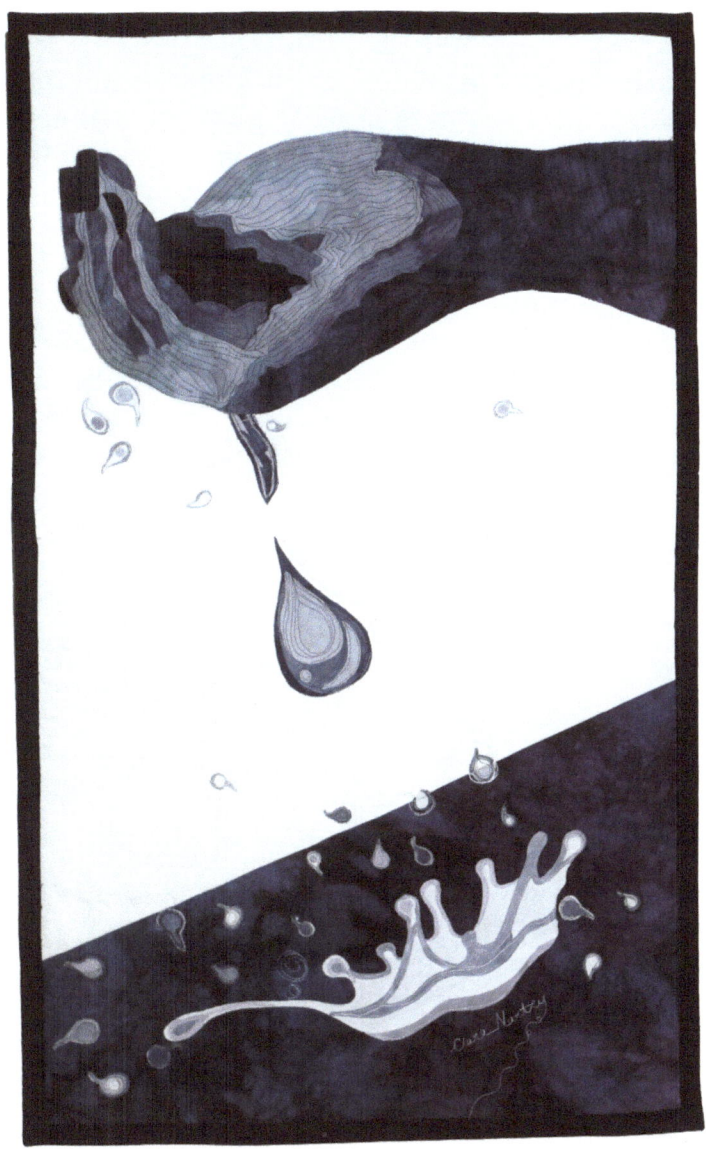

38" x 24"

Techniques: collage, stitch and dye

Tricia Purrington Deck

www.triciadeck.com

On Lake Willoughby in the Northeast Kingdom, all seasons are magical. There are summers where it looks like water skiers are skiing on clouds because of the reflection in the water. During winters, we see trucks driving on the lake for ice fishing. Last May my husband was at the lake and witnessed an amazing sight of the changing of seasons. The ice was breaking apart leaving winter behind and preparing for spring. He ventured out in a kayak and took several photographs. I was enthralled with the images and hearing about his experience.

When I saw the call for entry for Currents I knew I wanted to try and capture that magical moment in fabric. With the permission of my husband to use his photograph, I started on my entry. The quilt exhibits all three states of water: ice, liquid and gas within the clouds.

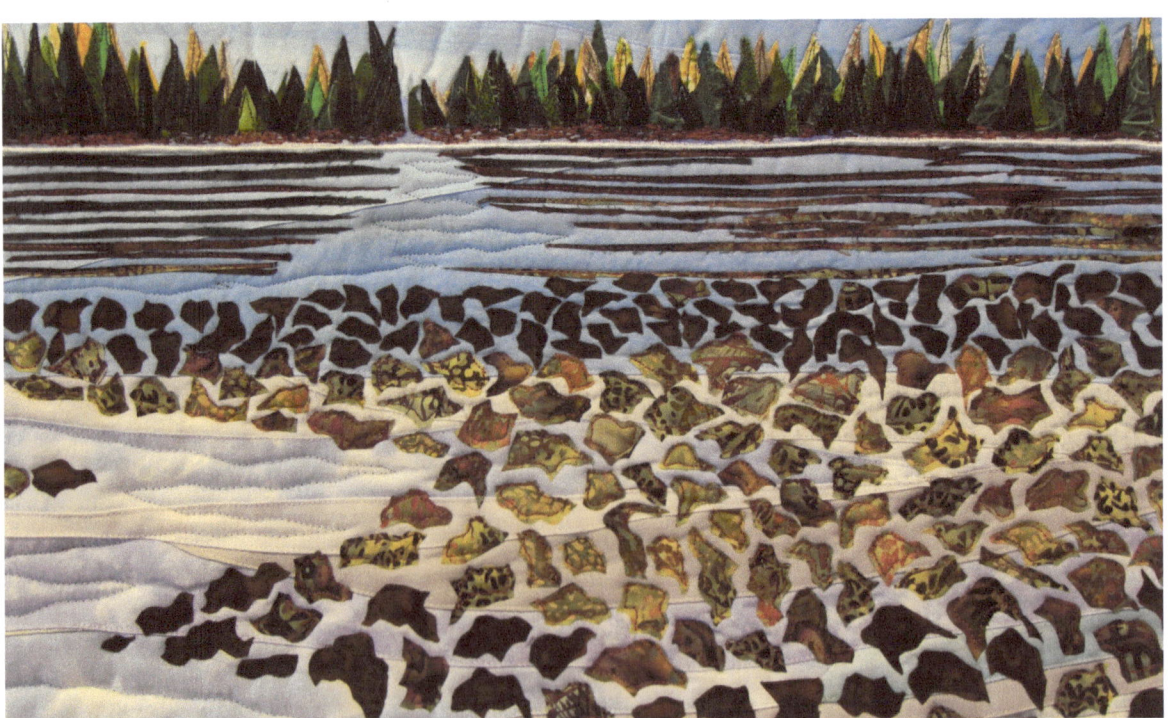

Magical Moment detail

Magical Moment

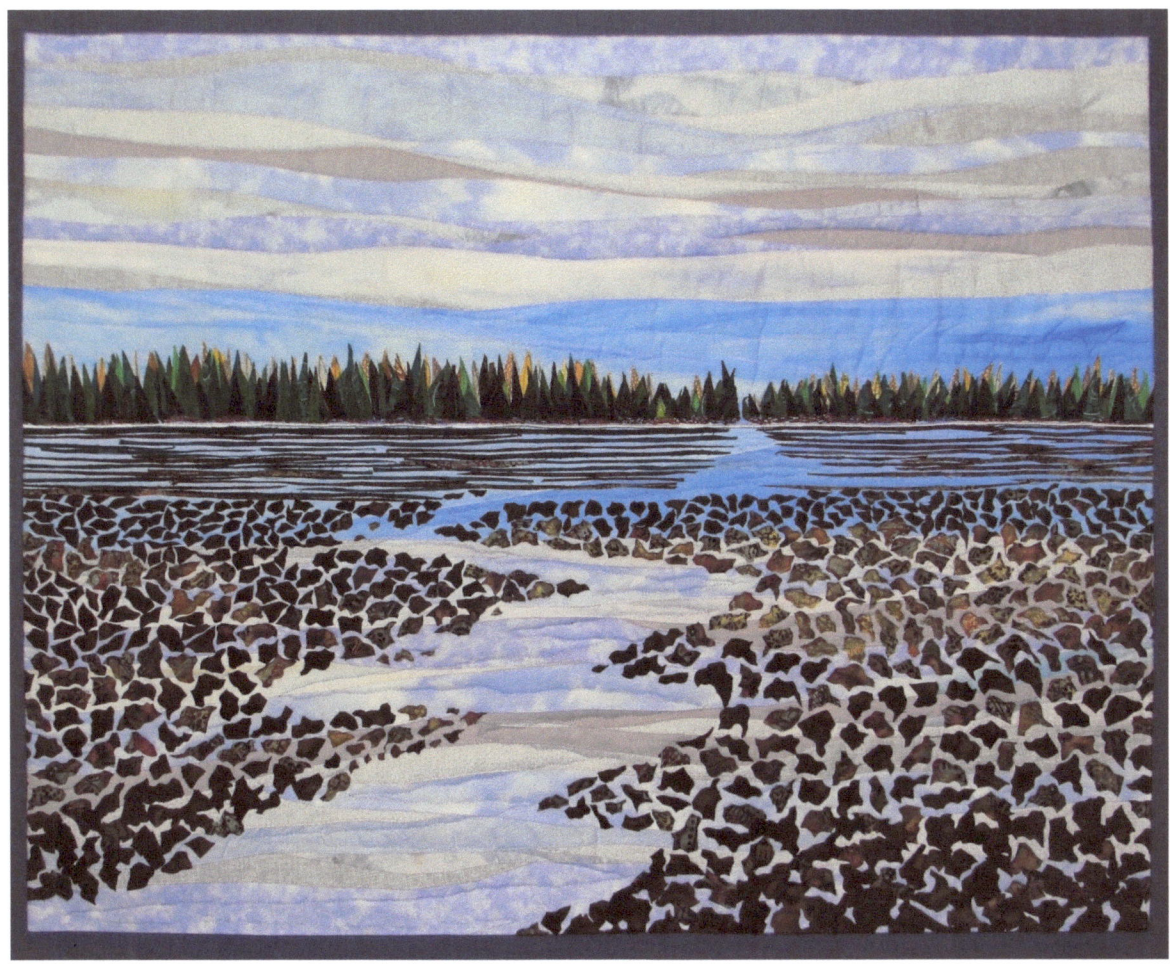

27" x 34"

Techniques: raw-edged appliqué, free motion quilting

Wen Redmond

www.wenredmond.com

Walking the road near my old home toward the reservoir was an almost daily ritual. There I would arrive, ready to sit, to contemplate as the water lapped my edges soft.

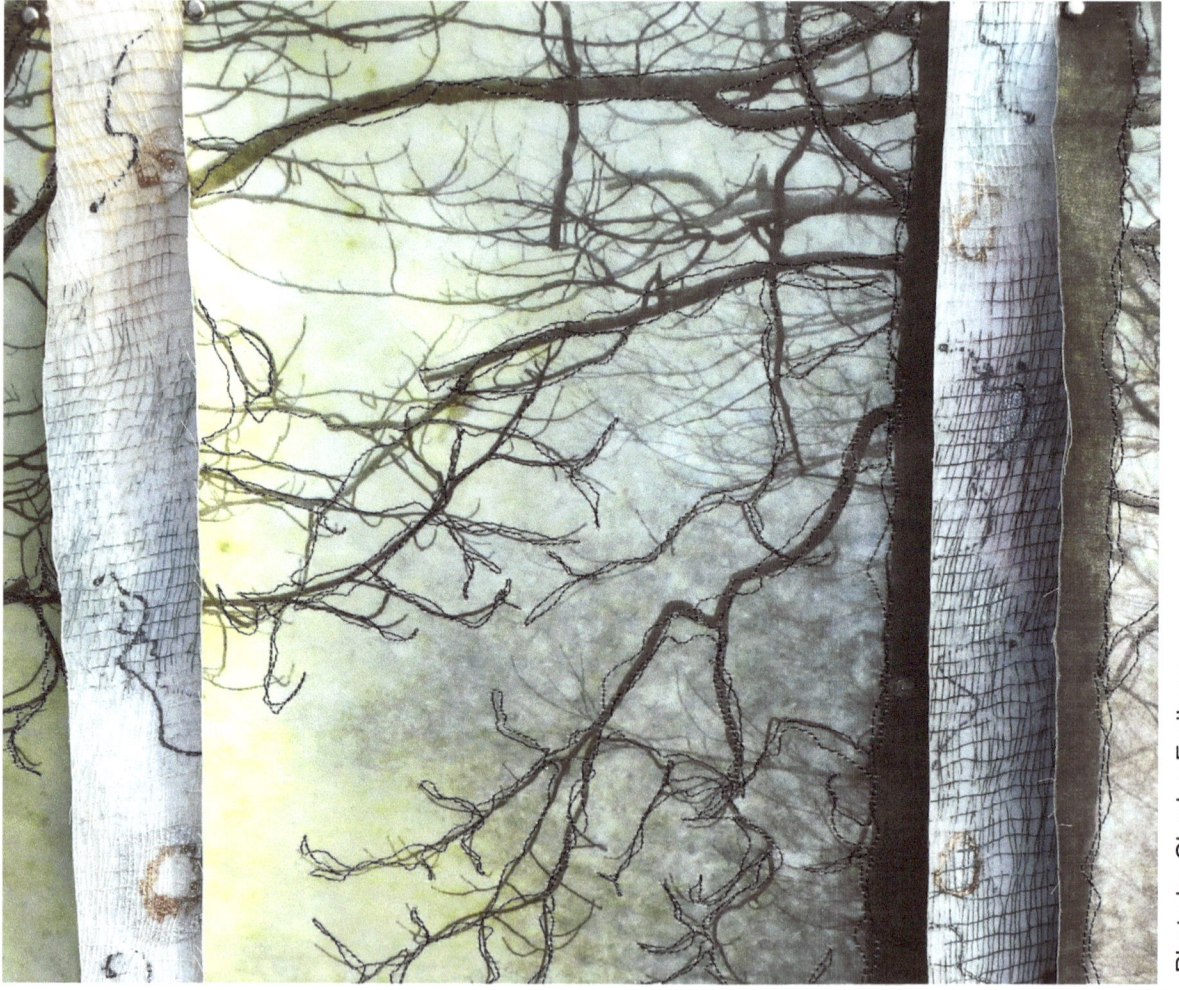

Crown Point detail

Photo by Charley Freiburg

Crown Point

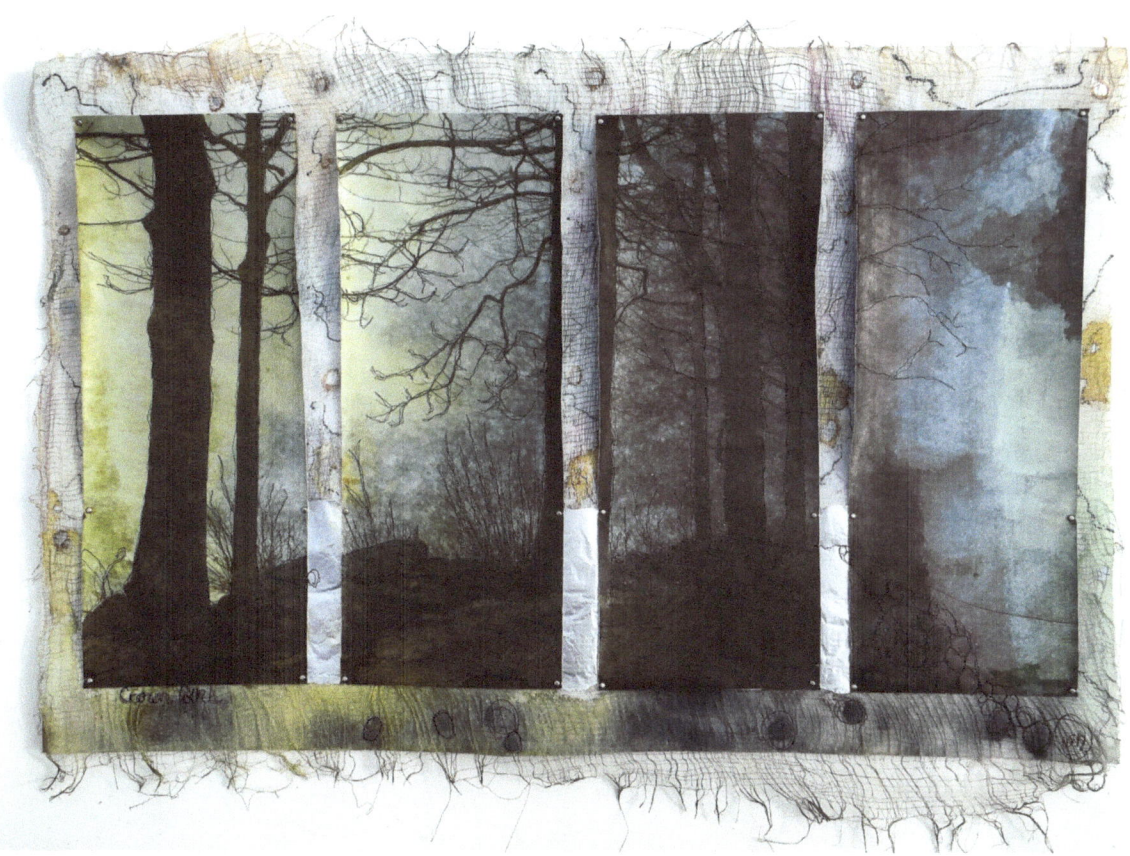

21" x 32"

Photo by Charley Freiburg

Techniques: digitally fused photograph divided and printed on silk charmeuse, quilted and attached with brads onto a free under collage substrate of lutrador, tea bag liners & cheesecloth

Wen Redmond

www.wenredmond.com

Sending myself to the lake, I paint cloth and remind myself what it's all for. Surrounded by nature, I immerse myself in my art. Allowing the inspirations to take me to that creative place I can reach near water and trees.

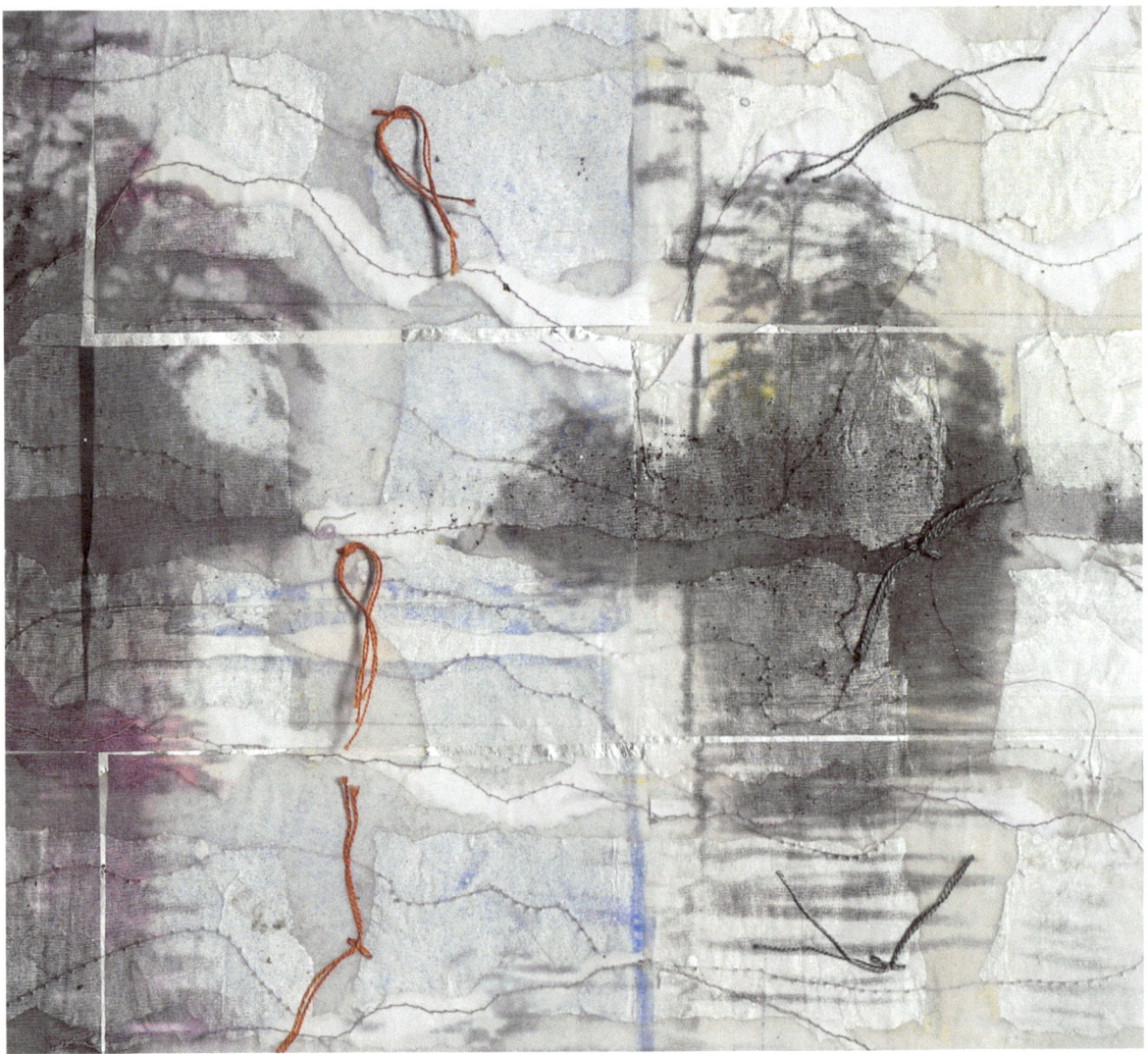

Photo by Charley Freiburg

Out Beyond detail

Out Beyond

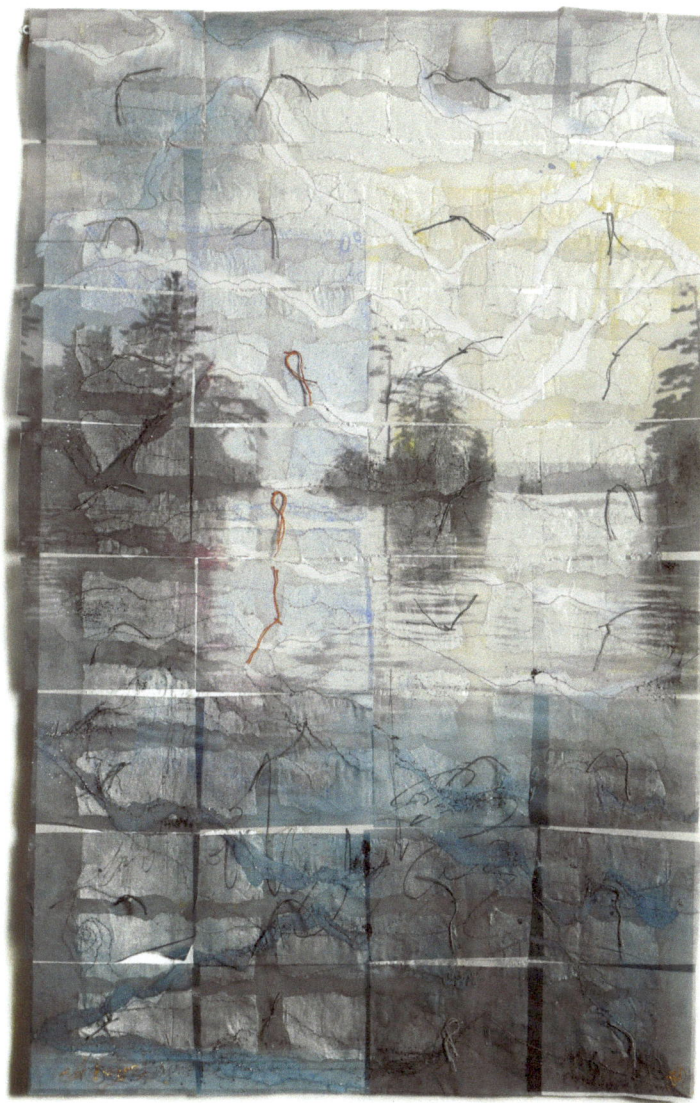

Photo by Charley Freiburg

32" x 22"

Techniques: Stitched silk organza was cut apart and layered on an interfacing background with stitched recycled tea bag liners; center ties of pearl cotton.

Judy Ross

www.artquiltsbyjudyross.com

I am intrigued by water and the way the light plays on it's surface. I used shades of blue because it makes me feel peaceful. I like to use shiny fabrics such as satin along with cottons because of the sheen and how the satin amplifies the quilting and seems to give the piece more motion.

Water Currents detail

Water Currents

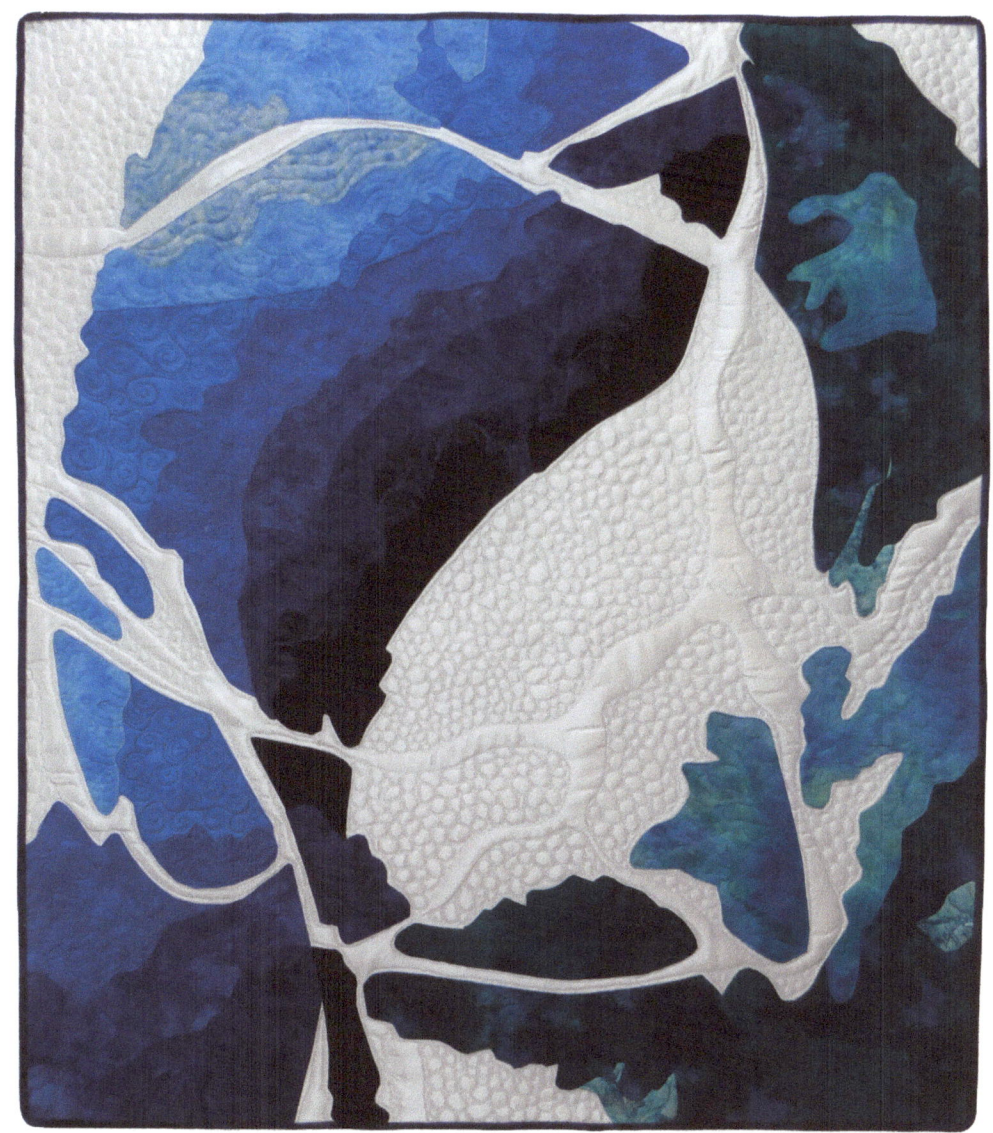

36" x 31"

Techniques: machine appliqué and machine quilting

Judy Ross

www.artquiltsbyjudyross.com

For this piece I was inspired by the ever shifting water reflections I saw in the harbor in Baltimore, Maryland. I spent hours taking photographs and was mesmerized by the ever changing pictures of the same body of water.

Shifting Reflections Baltimore Harbor detail

Shifting Reflections Baltimore Harbor

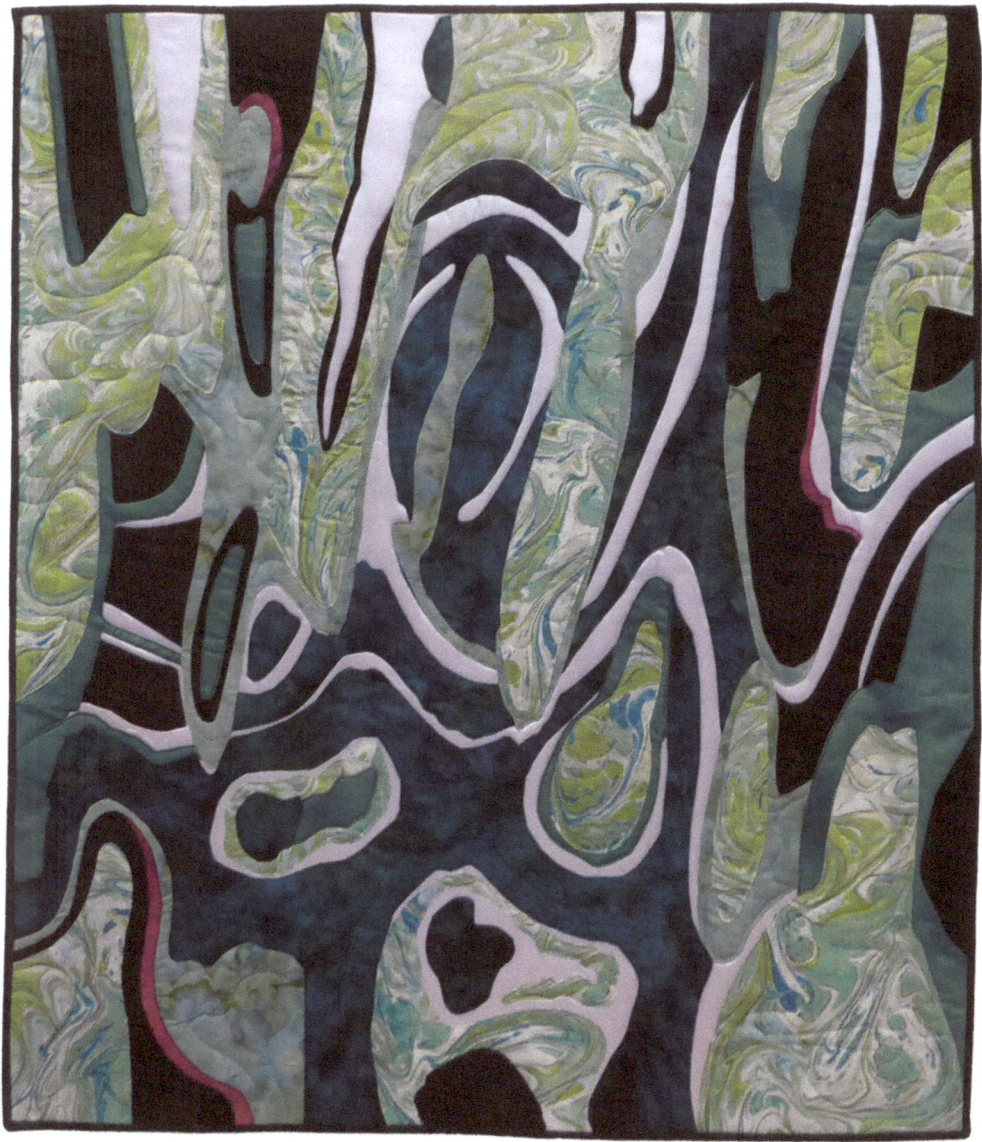

30" x 25"

Techniques: machine appliqué and machine quilting

Judy Ross

www.artquiltsbyjudyross.com

In this satellite view of an urban center, I like to show how water is the heart and life blood of the city. The water is at the city's hub and runs through it. Without water, the settlement would not have started and would not have grown and thrived.

Urban Sprawl detail

Urban Sprawl

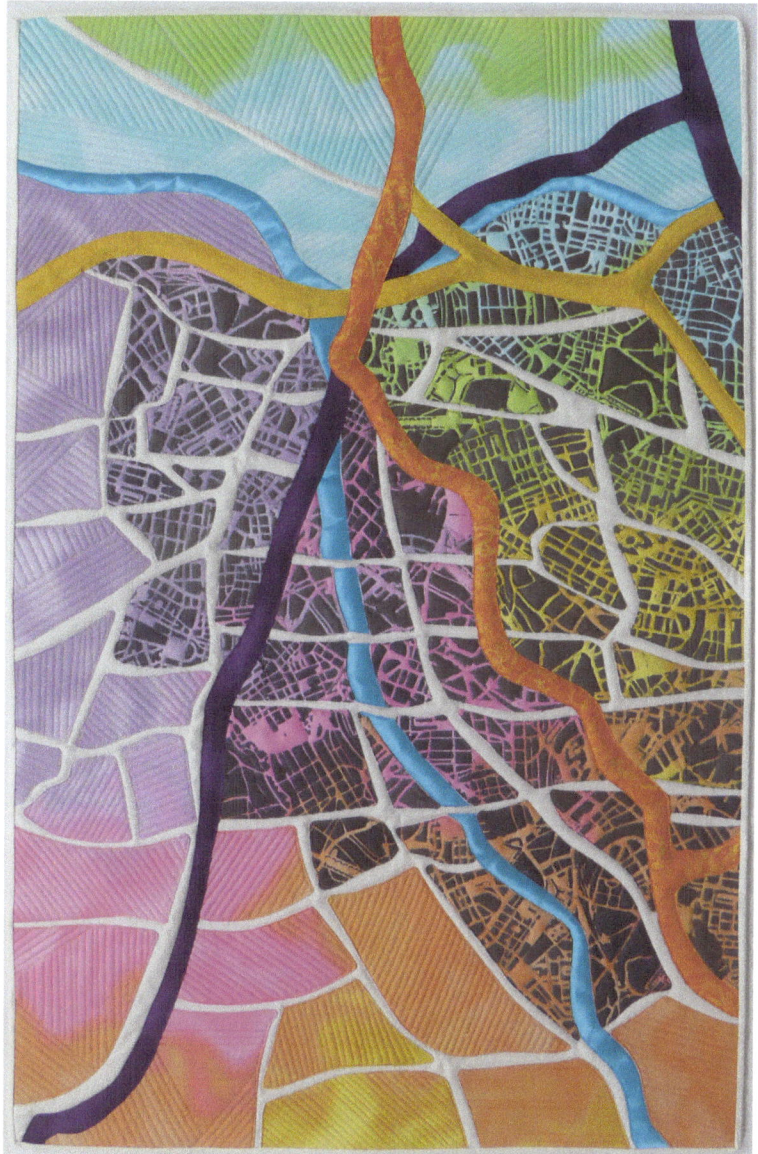

38" x 24"

Techniques: machine appliqué, machine quilting and template painted fabric

Gwyned Trefethen

www.gwynedtrefethen.com

The intent of painting with ink blended with shaving cream was pure, joyful experimentation. When an unexpected thin green line, reminiscent of a distant horizon appeared during the drying of the ink the scene was set. *Reflection #2* came alive with judiciously applied free motion machine quilting and thread painting.

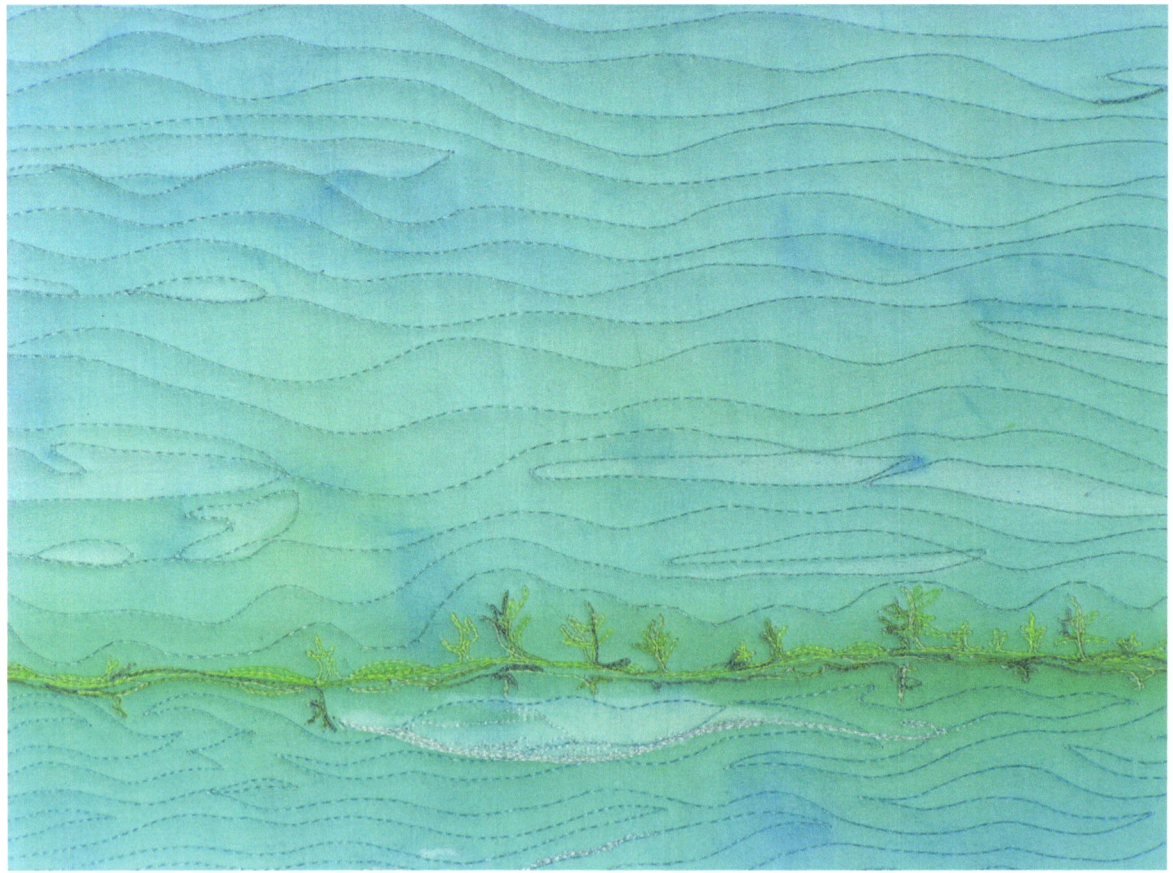

Reflection #2 detail

Reflection #2

13" x 20"

Techniques: Artist painted fabric was enhanced with thread painting and free motion machine quilting.

Nancy Turbitt

www.nancyturbitt.com

There is something magical about seeing a waterfall cutting through rock and pouring out from the lushness of a quiet forest. It's only water! Yet hundreds of thousands of people flock to view waterfalls like Niagara Falls each year.

Last year I was fortunate to visit Portland, Oregon in the spring and I spent an afternoon hiking up the trails near Multnoma Falls with an old friend. Like the falls in it's constancy of flowing water, my childhood friend and I reunited in a perfect expression of life and time alongside the backdrop of this magnificent waterfall.

Reunion detail

Reunion

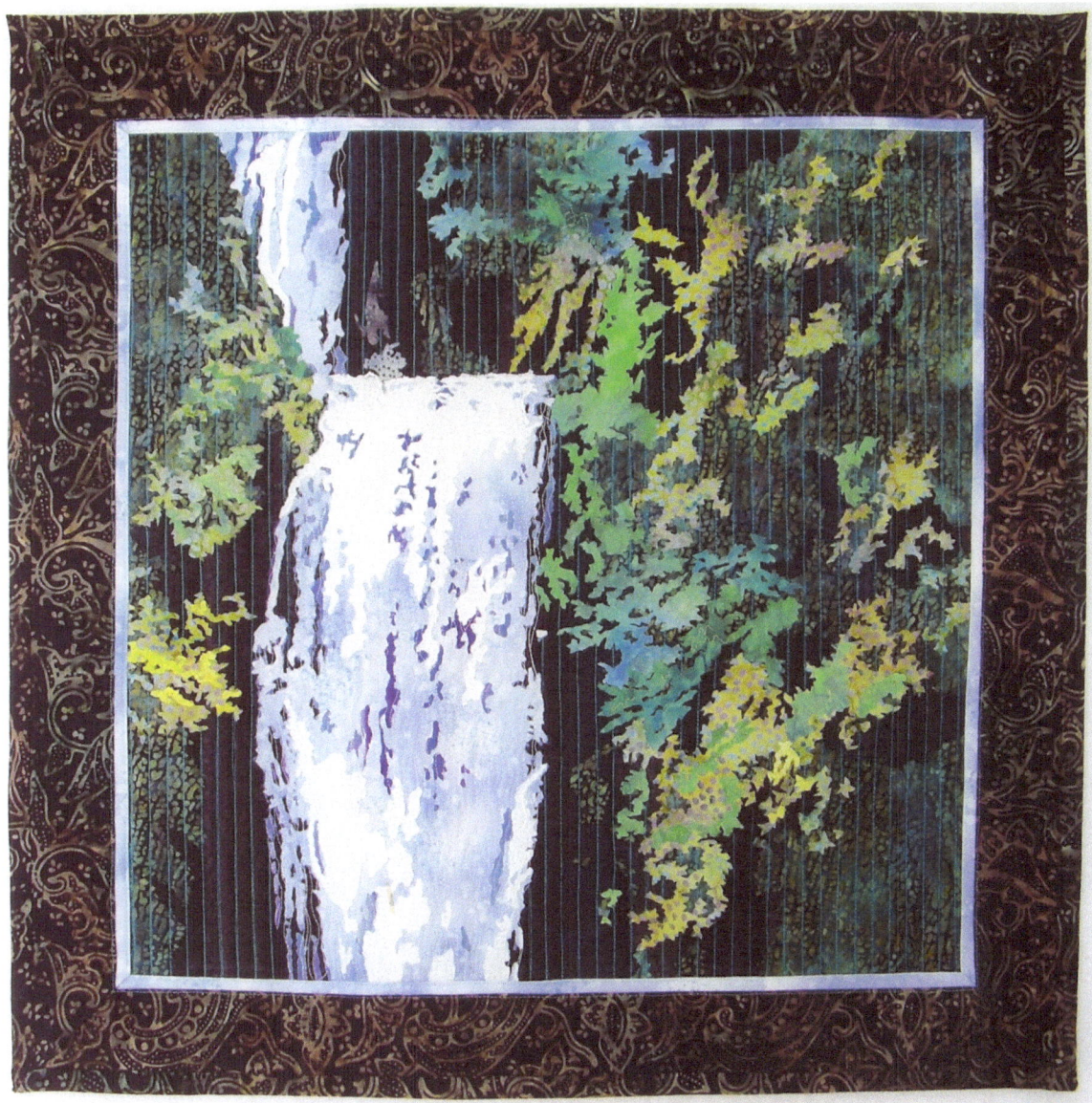

26" x 26"

Techniques: fused raw-edge appliqué and reverse appliqué; machine quilted

Allison Wilbur

www.allisonwilburquilts.com/wp/

A visit to the fish pond in my Japanese garden provides a tranquil start to my day, particularly in spring with a light rain falling. The shimmer, movement and changing colors of the water are mesmerizing; making worries fall away.

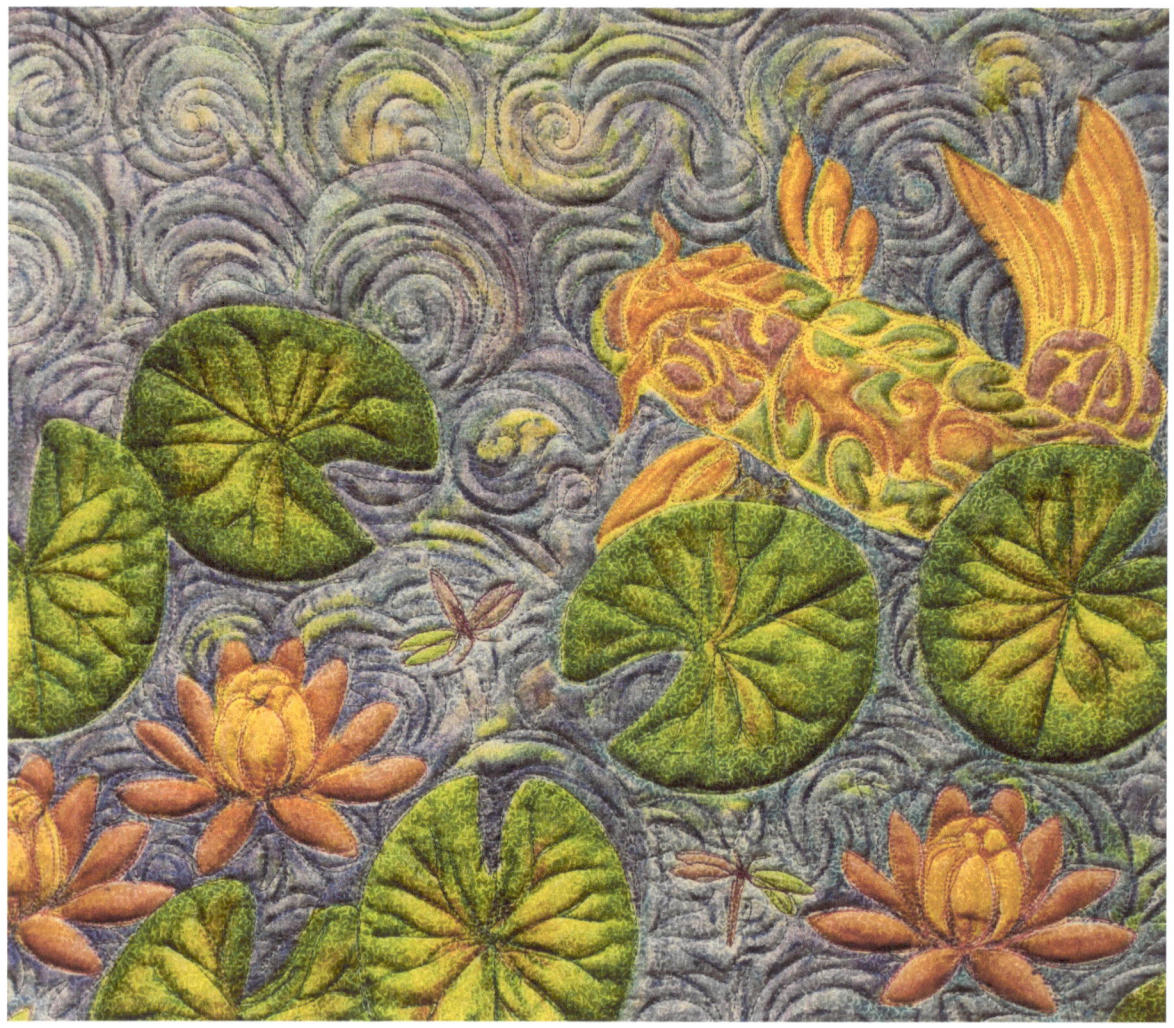

Spring Raindrops detail

Spring Raindrops

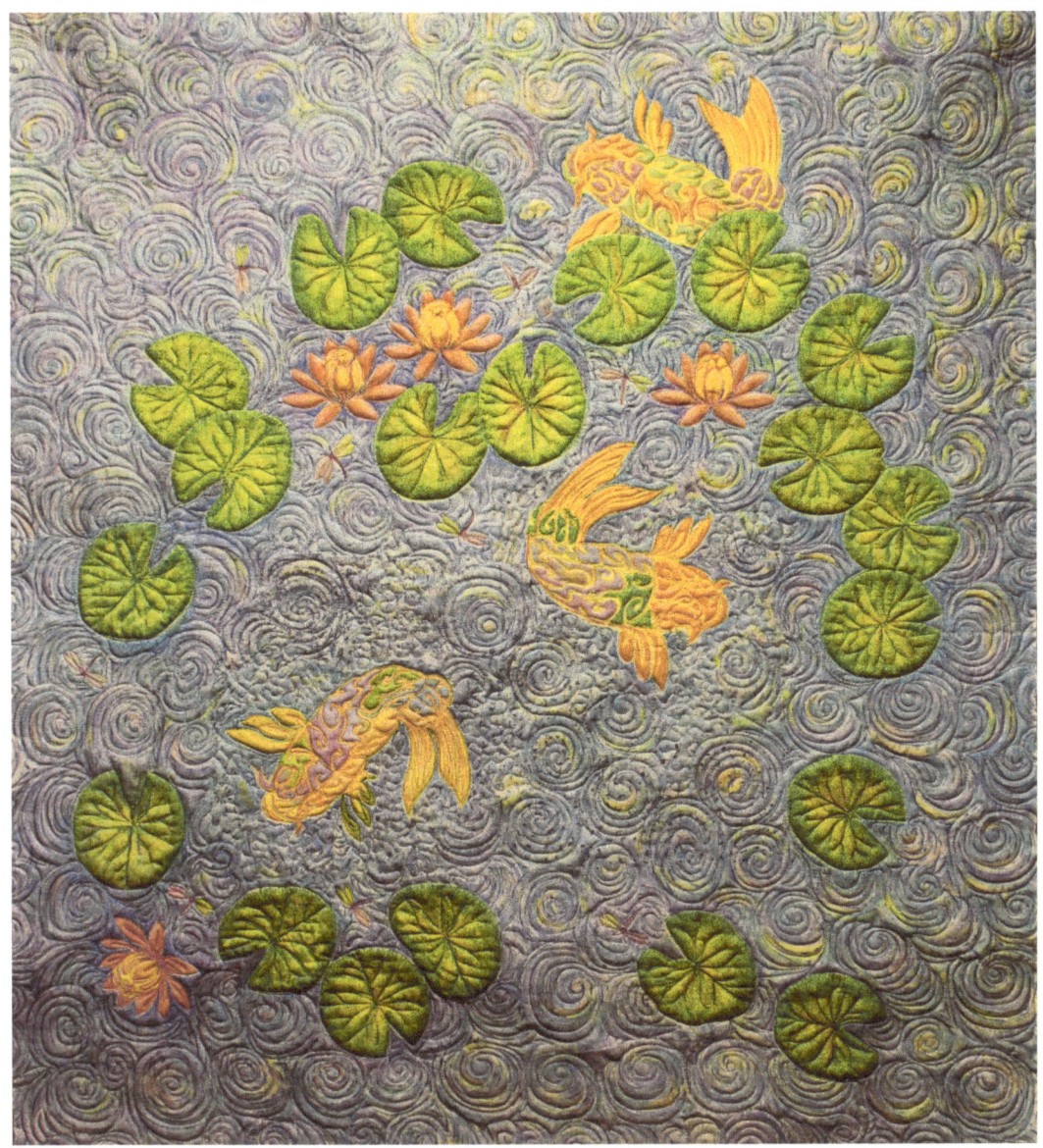

43" x 36"

Techniques: oil stick rubbings of water lily leaves and texture plates, stencils, machine quilting

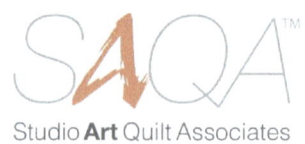

SAQA is a world-wide resource for information on the art quilt and the artists who create them. In addition to mounting museum-quality exhibitions that travel the world, SAQA documents the art quilt movement through exhibition catalogs and the continuing series of Portfolios, the art quilt sourcebook.

SAQA creates professional development opportunities for the membership that continue to address the ever-changing needs of the artist. From basic studio management to mastering current technology for both business and artistic purposes, SAQA members have access to a treasure trove of support for taking their artwork and career to the next level.

Over the past 25 years, SAQA has evolved into an active and dynamic organization that offers many services to our members as well as to the community at large. Our website provides visibility to the accomplishments of the artist members and gives members immediate access to information about exhibition opportunities, announcements of upcoming events and conferences, and other resources.

MA/RI regional blog: ma-ri-saqa.blogspot.com

SAQA website: www.saqa.com

Catalog design: Sue Bleiweiss

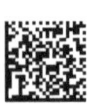
www.ingramcontent.com/pod-product-compliance
Lightning Source LLC
Chambersburg PA
CBHW050811180526
45159CB00004B/1631
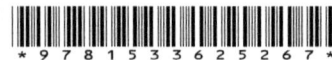